BRITAIN IN OLD PHOTOGRAPHS

CARLISLE
PEOPLE & PLACES

CHARLIE EMETT & J.P. TEMPLETON

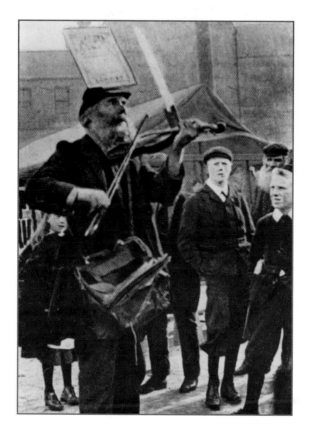

SUTTON PUBLISHING

Sutton Publishing Limited
Phoenix Mill · Thrupp · Stroud
Gloucestershire · GL5 2BU

First published 2003

Title page photograph: Carlisle character
Jimmy Dyer in 1895, playing his fiddle at
Carlisle Cross, site of the Roman forum.
Jimmy died in his father's pub at Stanwix
in 1907.

British Library Cataloguing in Publication Data
A catalogue record for this book is available from the
British Library.

ISBN 0-7509-3443-3

Typeset in 10.5/13.5 Photina.
Typesetting and origination by
Sutton Publishing Limited.
Printed and bound in England by
J.H. Haynes & Co. Ltd, Sparkford.

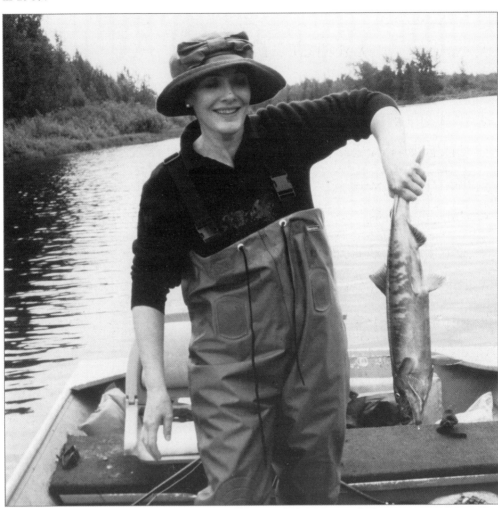

Like Izaak Walton, Fiona Armstrong (above), Border Television's much-loved newsreader and presenter, loves 'any discourse of rivers and fish and fishing'. Fishing is part of Carlisle's appeal; but there is much more to Carlisle than its sparkling rivers, appealing though they be. Carlisle, with its long and turbulent history, has been transformed into a beautiful, modern city with an eye to the future. It is the only city in Lakeland, a title it carries with pride.

CONTENTS

ACKNOWLEDGEMENTS

Our very special thanks to Anne Templeton, guardian of the Templeton Collection, probably the finest pictorial record of Carlisle yesteryear in existence. Throughout the preparation of this book, Anne has been unstinting in her devotion to our needs, not an easy task, and has shown that she is a real treasure. (Unless otherwise stated all pictures come from the Templeton Collection.) To Senator Edward Haughey LLD, DBA, FRCSJ, OBE, JP, most grateful thanks for allowing us access to Corby Castle grounds to photograph the dove-cotes and for the hospitality extended to us. Your kindness is much appreciated. Sincere thanks also to photographer Loftus Brown for permission to use his pictures of the Cumberland Show, Walter Tickner for his ever ready help with photographs of Carlisle, and Tony Wiseman for permission to use his photographs. To Stephen Brown for copy printing and Eagle Graphics, many thanks. To Ron Charters for help with the bees story, and Walter Graham for copy of the wild geese and fishing information, many thanks for your valued contribution to the book. Special thanks to Sutton Publishing's brilliant editorial team. It is always a great joy to work with such good friends, happy in the knowledge that we are all aiming for the same result – a publication that meets Sutton's very high standards. We apologise to anyone we have inadvertently omitted and share equally any errors.

Cumberland & Westmorland wrestlers.

INTRODUCTION

In AD 72 the Romans moved north from their newly established base at York and, under Petrillius Cerialis, crossed the Pennines over desolate Stainmore and marched along the Eden Valley as far as the junction of the Rivers Eden and Calder near the Solway Firth. There they built a fort, which they called Luguvalium. From that small beginning Carlisle evolved. It was a turbulent transition. Cerialis established a settlement where the castle now stands and the fort that housed his garrison, a turf and wood construction, was built where Carlisle Cathedral now stands.

For 350 years the Romans controlled Luguvalium, during which time the fort was rebuilt (in about AD 100) and Emperor Hadrian was forced to abandon his Scottish conquests (in about AD 130). In order to consolidate the northern frontier of his empire across the narrow Solway–Tyne isthmus he built a defence system that came to be known as Hadrian's Wall. Its garrison was transferred to a newly built stone fort at Petriana, known as Stanwix, on the northern bank of the River Eden. It was the largest camp along Hadrian's Wall and housed a regiment of cavalry 1,000 strong, which was always kept in a state of readiness. Luguvalium was demolished and replanned as a civil settlement.

There followed 250 years of wealth and security not equalled until the twentieth century. Luguvalium had a drainage system, many of the houses were well built, some

Badge of the Border Regiment.

of timber with tiled roofs. In accordance with Roman custom, the dead were not buried in inhabited areas. They were interred outside the 70 acres comprising Luguvalium. Roads radiated from the forum or market place north along what is now Scotch Street and over the River Eden, south along today's English Street and Botchergate, and westwards towards Caldergate.

So pronounced was the Roman influence on Luguvalium that it determined the future shape of Carlisle and its road pattern to the present day. Carlisle Cross or the Market Cross stands on the site of the Roman forum or market cross. From Roman times, whenever important notices have been read, proclamations declaimed and lists of the dead resulting from epidemics posted, this site has been used. For many years, until fairly recently, mileages to and from Carlisle were measured from Carlisle Cross.

When, in AD 685 St Cuthbert visited Luguvalium and was proudly shown around the city walls, he was very impressed by the remarkable workmanship of a Roman-built water fountain.

By that time, the word 'Luguvalium' had been corrupted in common usage, to 'Luel'. Later, the Celtic word word 'Caer', meaning 'fort', was added. Thus, in the vernacular of the inhabitants of Luguvalium, it became known as 'Caer-Luel', although scholars used the word 'Lugubalia' until about AD 1400.

In 875 AD heathen Danes under Halfdan sacked Carlisle with such savagery that for the next 200 years no one could differentiate between the town and the surrounding country. The walls were demolished, the town burned and every man, woman and child killed. The Danes then moved northwards and eastwards into Northumbria and Yorkshire. In AD 925 the Norse arrived in Carlisle. They came by way of Ireland and the Solway Firth and were much less warlike than the Danes. They settled along the River Eden and in scattered farmsteads and hamlets in the Cumbrian dales.

When, in 1072, Gospatric, Earl of Northumberland, who had taken possession of Carlisle in 1070, was deprived of his earldom, he handed over Carlisle to his son Dolfin, who became its ruler until 1092, when William Rufus drove him out. Carlisle is the only English city not mentioned in Domesday Book because when the Book was compiled in 1086, it was still part of Scotland. William Rufus restored Carlisle and brought it back into England. It was the last city to become English and has remained English ever since.

Henry I, who succeeded William Rufus, visited Carlisle in 1132. Henry liked the Scots and his wife Edith was the daughter of King Malcolm of Scotland. Even so, Henry had no intention of returning Carlisle to the Scots. He began to strengthen Carlisle Castle. In 1133, he founded the diocese of Carlisle and the Augustinian priory, which he had established in 1102, became a cathedral dedicated to the Blessed Virgin Mary.

Henry II visited Carlisle to gain the allegiance of its citizens and granted the city's first charter in 1158. When, in 1165, King Malcolm died his brother became King of Scotland and in 1174 besieged Carlisle without success. Throughout the reign of Richard I and most of that of his successor, King John, the Scots continued to press their claim to Carlisle.

In 1216 Alexander II of Scotland invaded England and took Carlisle city and castle. In 1217 Henry III ordered Alexander II to stop creating Border strife and go back to Scotland. Substantial financial inducement accompanied this order and pleased Alexander who, in the vernacular, 'took it and buggered off'.

For the following eighty years Carlisle was peaceful. In 1251 Henry III gave Carlisle a second charter to replace the one granted to it in 1158, which had been destroyed by fire. This second charter was lost in a great fire of 1292, which gutted most of Carlisle. In March 1296 the Earl of Buchan invaded England with 40,000 men and attacked Carlisle. The attack was repulsed and the Scots returned home.

In 1315 Robert the Bruce, victor of Bannockburn in 1314, determined to capture Carlisle because his father had commanded it from 1295 to 1297. The siege of Carlisle was one of the most famous in the history of the Border wars. Led by Bruce himself, the Scots advanced on the city, which was defended by Sir Andrew de Harcla with his 'Kendal archers, all in green'. For eleven days the siege continued, but then Bruce called off his army and retired, leaving behind all his equipment. On 3 March 1323, Sir Andrew was unjustly hanged at Harraby; and with this peacemaker now dead, hostilities broke out just north of Carlisle, although England and Scotland were not at war. The Border became known as the Debatable Land.

By the middle of the fourteenth century, Carlisle was again falling into disrepair, and within the city standards of hygiene were low enough for the Black Death to strike. In 1352 Edward III granted a further charter to Carlisle, which established the city's right to 'a free guild and a free election of their mayor and bailiffs'. It also granted Carlisle the right to hold a Great Fair. This fair is still proclaimed every 26 August at 8 a.m. from the steps of Carlisle Cross.

In 1542, when Henry VIII declared war on Scotland, Carlisle once again became a military headquarters. For the decade following Henry VIII's death in 1547 serious attempts were made to bring order to the Debatable Land by policing it, and this was partially successful.

In 1637 Charles I granted a new charter, which still governs the city. One of the privileges it granted was the right to carry the royal sword and maces before the mayor in procession. This gave the citizens the right to govern themselves, for the sword is the emblem of civic independence. It is always carried sheathed to denote the reserve of force behind the civil power. The maces carry the arms of England, showing that the authority entrusted to the mayor during his or her year of office is authorised by the Crown. During the Civil War, Carlisle became the most important royalist stronghold in the north and, as such, a prime target for Cromwell's army.

A visitor to Carlisle in 1759 described the city as 'a small deserted, dirty city, poorly built and poorly inhabited'. Another visitor, in 1773, said, 'the streets are kept remarkably clean, the principal of which is spacious and contains many modern and elegant houses.' By the last quarter of the eighteenth century the citizens of Carlisle were beginning to enjoy a fuller and safer standard of living. The streets were lit by lamps, a textile industry had become established, and a library had opened.

On 27 October 1780, the *Carlisle Journal* began publication. By 1800 the population of Carlisle, which in 1763 was 4,000, had grown to 9,500.

Weaving was Carlisle's main industry but by 1807 the city was manufacturing printed cottons, hats, whips and hooks. It also had a soap boilery, tanners, skinners, three foundries and five banks. With the arrival of the Age of Steam, Carlisle became much involved with the expansion of the railways. By 1876 seven railway companies had their termini at Carlisle's Citadel station.

There was a lot of opposition from the locals who brewed their own beer when, in 1756, Carlisle's first brewery was set up on the River Caldew. Yet by the beginning of the nineteenth century four breweries were in production near the river. They served Carlisle and the surrounding area for well over a century, producing 18,500 barrels annually.

Carlisle's armorial bearings are quite recent, having been drawn up, registered and recorded by letters patent in September 1924. As the corporation's responsibilities developed and diversified in the nineteenth century, departments were set up around the city centre, mainly in Fisher Street. The council and its committees met in the Town Hall. Then, on 12 March 1924, a new eleven-storey civic centre was opened at the bottom of Rickergate.

Today, industry is investing heavily in and around Carlisle, which is superbly served by road, rail and air. Moreover, private industry and investment has been matched by the public sector to such an extent that Carlisle has become the worthy capital of Cumbria, England's most beautiful county.

Several nationally and internationally known firms are based in Carlisle. Among them are Carrs of Carlisle, the biscuit people, The Metal Box Co. Ltd, that makes a large variety of tin containers, Cowans Seddon and Co. Ltd, specialists in harbour, dockyard and railway installations, the Penguin Confectionary Co. Ltd, that makes medicated lozenges and 'nipits', and the world-renowned civil engineering giant, Laings.

Carlisle is England's largest city, even larger than London. It covers an area of 398 square miles (1,035 sq km), and its borders stretch from Scotland in the north almost to the Lake District in the south, and from the North Pennines in the east to the Solway Firth in the west. Its lowest point is at sea level on the Solway Firth shore and its highest point is Cold Fell at 2,041 feet (622 m) above sea level.

There is a warmth about Carlisle that is missing in many cities, and the red sandstone of which it is built may, in part, account for this. Carlisle's castle, its magnificent cathedral, its showy railway station, its brilliantly conceived pedestrianised city centre and the many grand buildings along the streets will certainly inspire; but the warmth that Carlisle generates comes from another source, the citizens of Carlisle themselves. They radiate warmth and friendship; they are a lovely lot.

1

Carlisle Castle & the Border Regiment

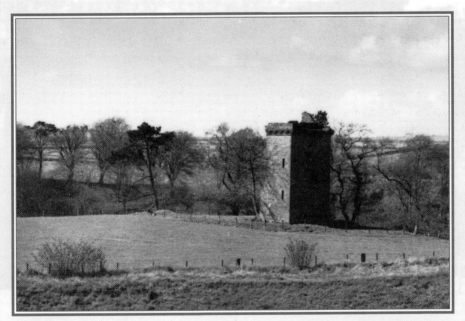

Carlisle Castle was built by William II (Rufus, 1087–1100), at a time when the separate kingdoms of England and Scotland were at loggerheads with each other and the English–Scottish border was fluid. As a further line of defence against invading Scots, border towers were built along the disputed frontier. Gilnochie, shown here, was the closest of these border towers to Carlisle Castle.

The tensions along this disputed frontier were further embittered by the reivers, thieves who spent their lives cattle rustling.

Kinmont Willie, a Scottish firebrand, was captured by the English during a truce and imprisoned in Carlisle Castle. The manner of his capture infuriated the Scots, who determined to free him without delay. On 13 April 1596, a very dark and stormy night, a Scottish rescue party made a perilous crossing of the fast flowing River Eden, which was swollen with heavy rains, and rescued Kinmont Willie. The English spotted them and gave chase as they made their escape to the roaring river, and without hesitation, set about crossing it. The pursuing English reined in at the riverbank, convinced that nothing could cross the angry river and that Kinmont Willie and his rescuers would be swept to their deaths. They were wrong; Kinmont Willie and his rescuers survived.

was not through this postern gate, on the west side of Carlisle Castle, that Kinmont Willie made his escape on 13 April 1596, as is generally supposed. His rescuers dug under the postern gate and he escaped that way. Times change and this picture shows a 'little miss' trying to get into the castle.

The battle honours of the Border Regiment do not stop at the relief of Ladysmith. More were earned during the First and Second World Wars and other conflicts. When old soldiers of the Border Regiment reminisce, they invariably do so with justifiable pride.

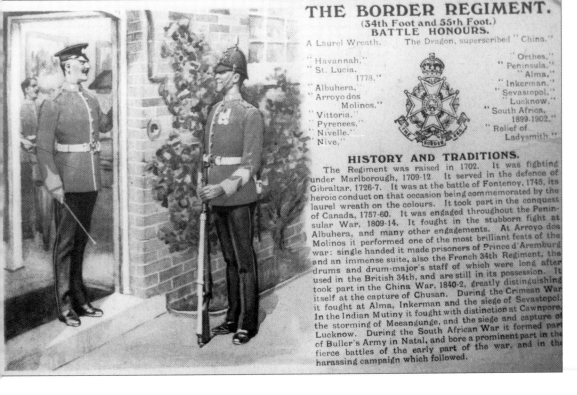

THE BORDER REGIMENT.
(34th Foot and 55th Foot.)
BATTLE HONOURS.

A Laurel Wreath. The Dragon, superscribed " China."

" Havannah," " Orthes,"
" St. Lucia, " Peninsula,"
 1778," " Alma,"
" Albuhera," " Inkerman,"
" Arroyo dos " Sevastopol,"
 Molinos," " Lucknow,"
" Vittoria," " South Africa,
" Pyrenees," 1899-1902,"
" Nivelle," " Relief of
" Nive," Ladysmith,"

HISTORY AND TRADITIONS.

The Regiment was raised in 1702. It was fighting under Marlborough, 1709-12. It served in the defence of Gibraltar, 1726-7. It was at the battle of Fontenoy, 1745, its heroic conduct on that occasion being commemorated by the laurel wreath on the colours. It took part in the conquest of Canada, 1757-60. It was engaged throughout the Peninsular War, 1809-14. It fought in the stubborn fight at Albuhera, and many other engagements. At Arroyo dos Molinos it performed one of the most brilliant feats of the war: single handed it made prisoners of Prince d'Aremburg and an immense suite, also the French 34th Regiment, the drums and drum-major's staff of which were long after used in the British 34th, and are still in its possession. It took part in the China War, 1840-2, greatly distinguishing itself at the capture of Chusan. During the Crimean War it fought at Alma, Inkerman and the siege of Sevastopol. In the Indian Mutiny it fought with distinction at Cawnpore, the storming of Meeangunge, and the siege and capture of Lucknow. During the South African War it formed part of Buller's Army in Natal, and bore a prominent part in the fierce battles of the early part of the war, and in the harassing campaign which followed.

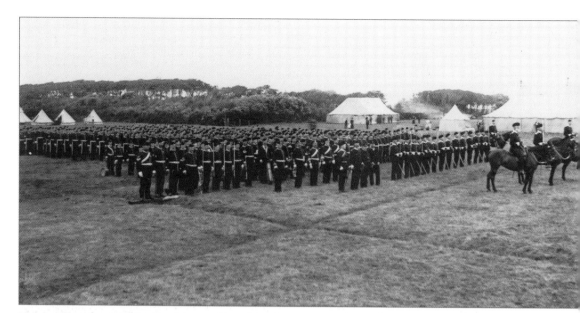

Conscription was still in the future when this picture was taken. These men are all volunteers of the 1st Battalion, the Border Regiment, at their Blackpool camp in 1898.

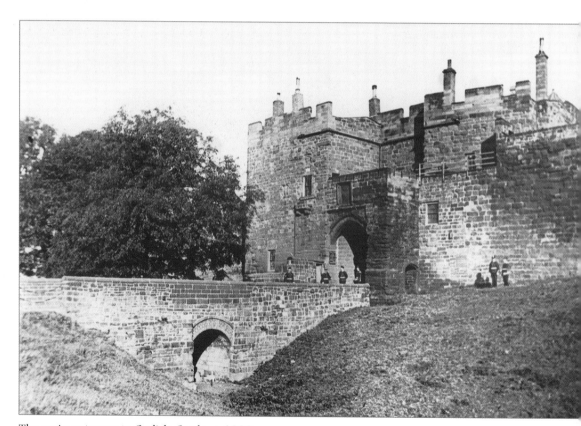

The main entrance to Carlisle Castle, *c*. 1900.

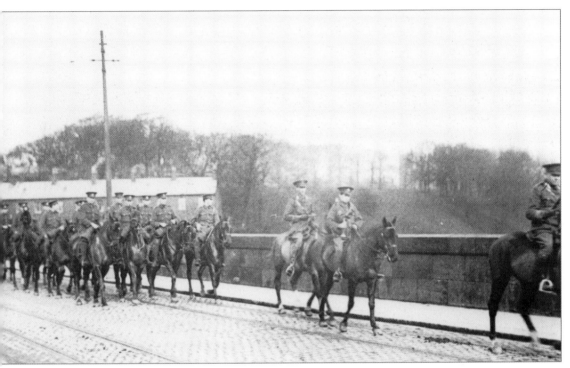

Westmorland and Cumberland Yeomanry, under the command of Lt Col Hassell, crossing Eden Bridge, Carlisle, in 1912.

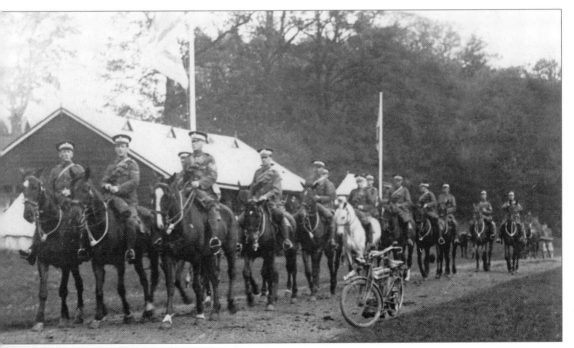

Westmorland and Cumberland Yeomanry on manoeuvres in 1912.

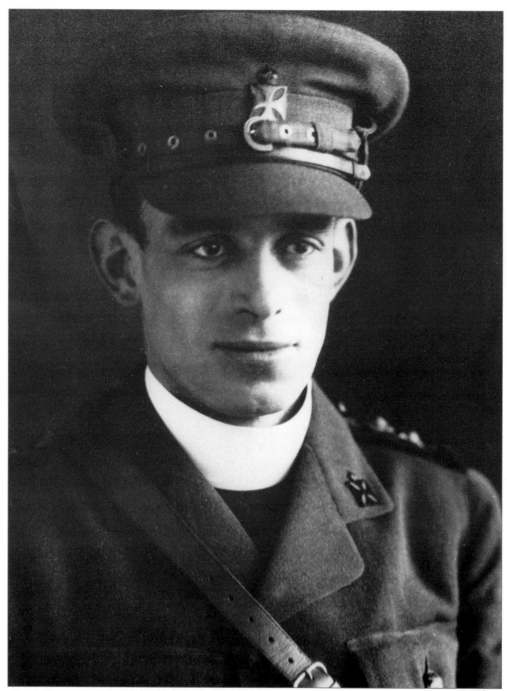

Theodore Bayley Hardy, vicar of Hutton Roof from 1915 to 1918, who loved nearby Carlisle and spent as much time there as he could, was appointed Chaplain to the Forces in August 1916. He was attached to the 8th Lancashire Regiment and the 8th Somerset Light Infantry. He was awarded the DSO in July 1917, the MC in October 1917 and the Victoria Cross in April 1918. He was appointed chaplain to the king in September. In October, while crossing a bridge in Rouen, he was wounded by a sniper, and on the 18th, he died of his wounds.

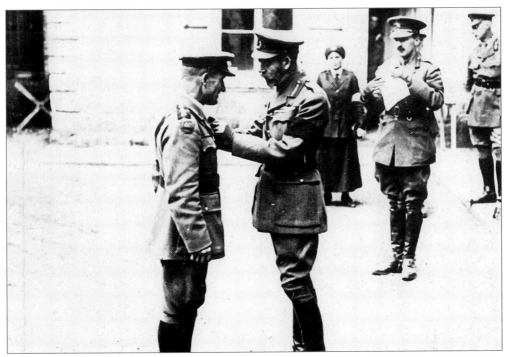

Theodore Bayley Hardy receiving his VC from George V in April 1918.

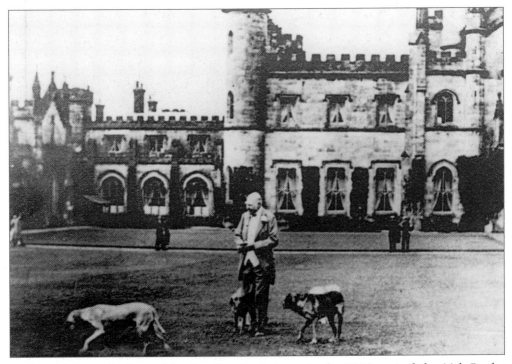

Lord Lonsdale on the lawn of his Lowther Castle home in the 1920s, raised the 11th Border Regiment, the Lonsdale Battalion, with its distinctive badge.

Laying up the colours of the 2nd Battalion, Border Regiment, outside Carlisle Cathedral in 1924. Pictured front, left of centre, is Dean Rashdall, who died the same year. Lt Col H.W. Gibb DSC is shown facing the dean.

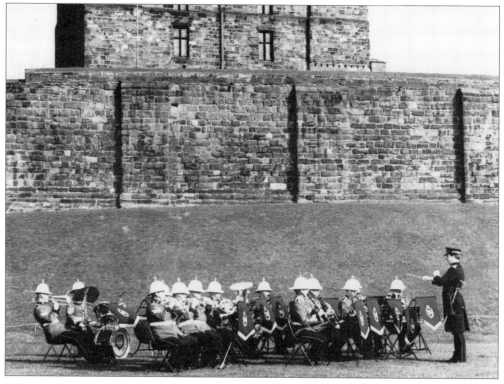

'All together: one, two, one, two, three, four. This is better than conducting a bus.'

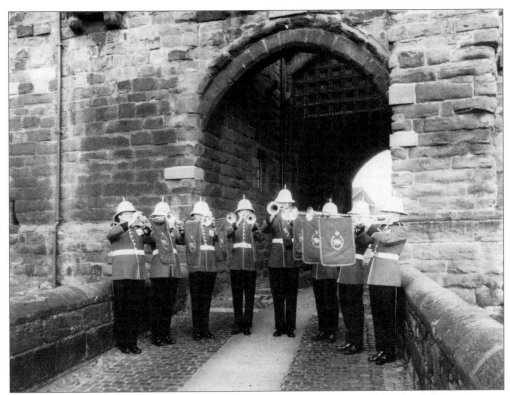

The King's Own Royal Border Regiment giving a musical half hour in front of the castle. David Milgate is the band master.

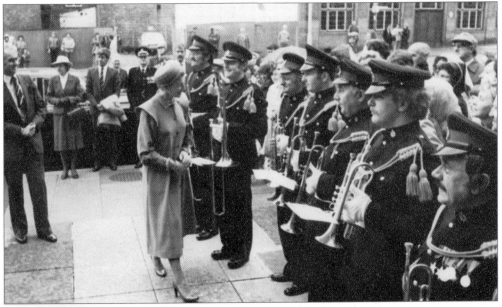

HRH Princess Alexandra, seen here on a private visit to Carlisle in 1982, is colonel-in-chief of the Border Regiment.

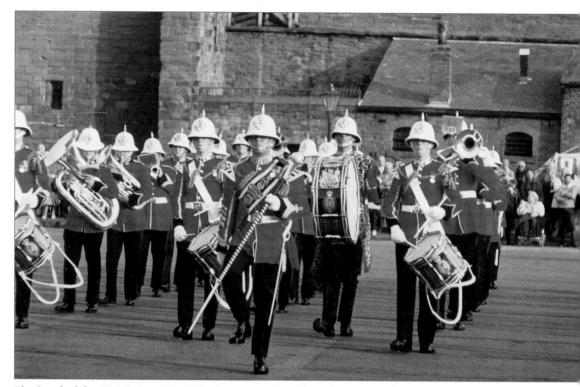

The band of the King's Own Royal Border Regiment beating the retreat.

An integral part of the British Army, soldiers of the KORBR maintain the highest traditions of this famous regiment, whose home is Carlisle Castle. The regiment's future is in good hands.

2

A Growing City

Following a long and turbulent early history, during which Carlisle's city walls were demolished by raiding Scots on several occasions, Carlisle in the Middle Ages once more became a walled city. Set into the city walls were three formidable gateways with thick studded gates that were opened daily at sunrise and closed at sunset. These gateways, designed for use rather than beauty, were very strong; they needed to be because they protected the city. The English gate was sited to the south of the city, facing towards where Carlisle's railway station is today.
The English gate is no more.

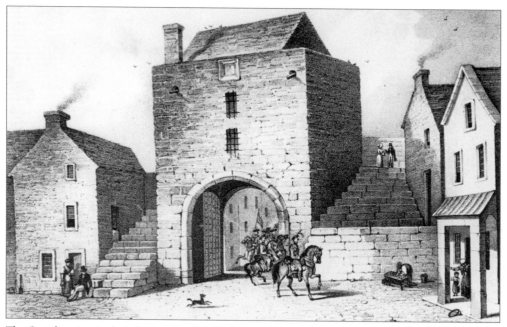

The Scotch gate stood at the northern end of Scotch Street and for part of its life was also used as a debtors' prison. When, in 1745, Charles Edward Stuart, 'Bonnie Prince Charlie', led a rising to restore his father to the English throne, several chiefs of the Scottish clans who supported him were captured by the English at Carlisle, and had their heads displayed on the Scotch gate.

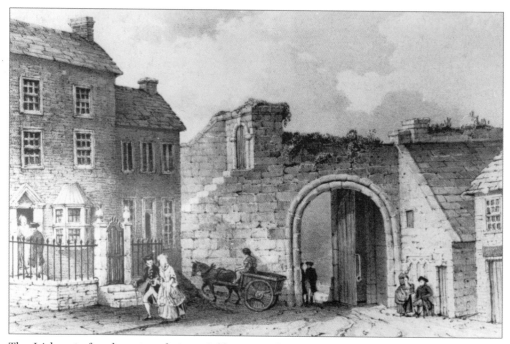

The Irish gate faced westwards into Caldergate. Like the English and Scotch gates, it was a gaunt structure, built to deter the most determined of nocturnal intruders. Like the other two gates, the Irish gate has long since gone.

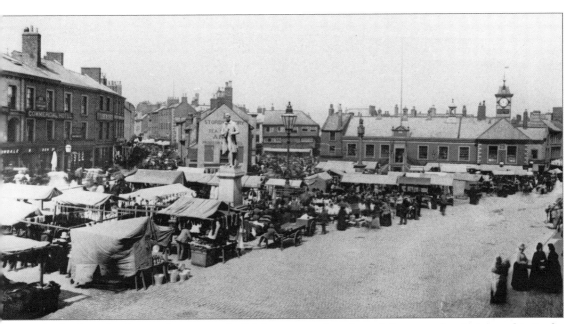

From as far back as the thirteenth century Carlisle's economy has depended on merchants engaged in trade, which was regulated by the burgesses, the richest members of the community. Trading was done through markets and fairs, many of which were local. In 1882, when this picture was taken, a weekly market was held in the city centre around Greenmarket and Town Hall Square. Steel's monument is left of centre with, directly behind it, Glover's Row.

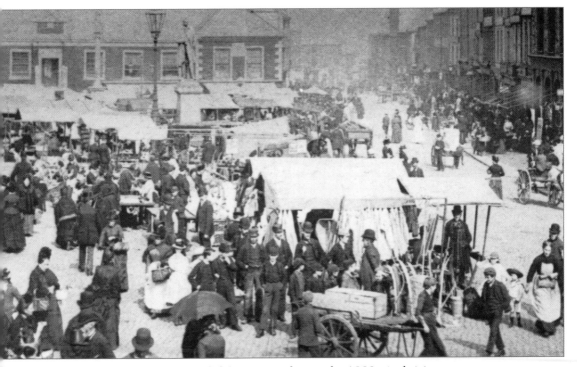

No matter which way you look at it, Carlisle's open market, in the 1880s, is thriving.

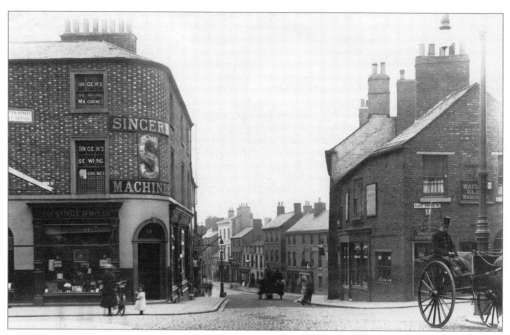

The twentieth century has dawned and has brought the age of advertising to Carlisle. This is the end of Scotch Street, looking down Rickergate. It was at this crossing that the Scotch gate stood.

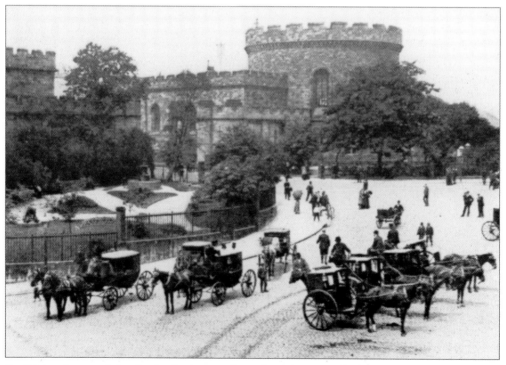

Carlisle's cabs are plying for trade close to the railway station, which is out of view to the left, *c.* 1900. In the background are the courthouses. At that time all Carlisle's vehicles were horse-drawn; but change was imminent.

Laying tramlines at the junction of Lowther Street and Warwick Road in 1900 was a complex business.

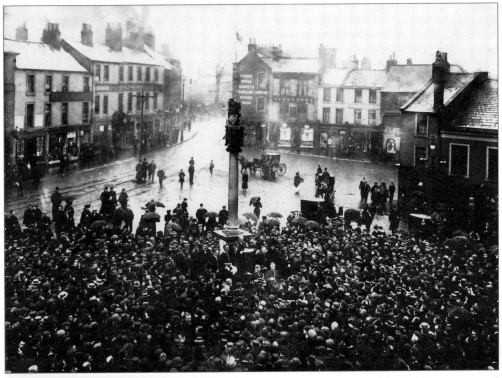

In 1901 the country mourned the death of Queen Victoria. In Carlisle, the mayor and corporation officials announced the late queen's death from the Carlisle Cross.

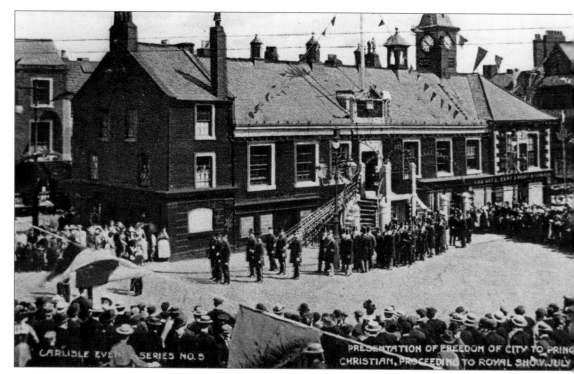

Prince Christian being presented with the freedom of the city of Carlisle prior to visiting the Royal Show
July 1902.

Moorville, at the northern edge of Carlisle on the main road to Scotland, 1905. Today it is the site
Morrison's supermarket.

Kingstone Road, looking towards the centre of Carlisle, in the winter of 1906. The leafless trees bring a touch of rural England to this urban scene, which is brought to life by the smiling ladies and the border collie, which has its eyes on the young man in the otherwise empty road.

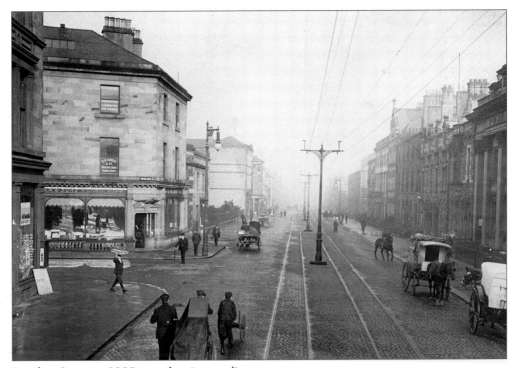

Lowther Street, *c.* 1908, now has its tramlines.

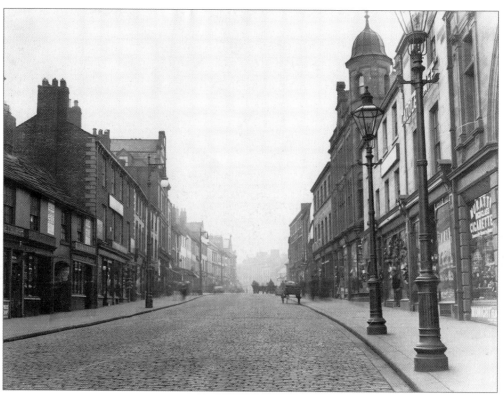

Looking north along Scotch Street, Carlisle, *c.* 1910.

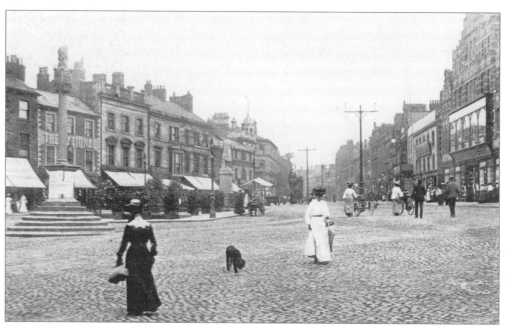

The centre of Carlisle, *c.* 1910. There is a tram in the centre background and one of the ladies, right of centre, has a tricycle.

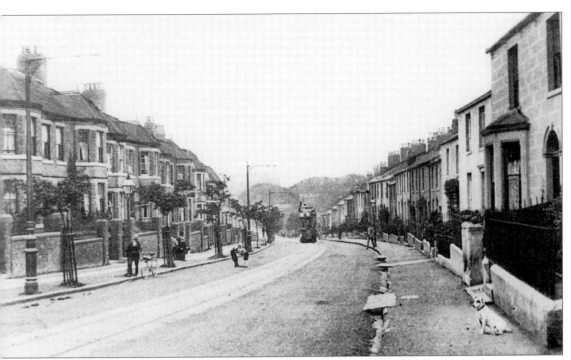

tterby Street, *c.* 1920. Two boys are wrestling on the street despite the approaching tram. Anyone trying to rrestle on Etterby Street today would be lucky to escape with his life.

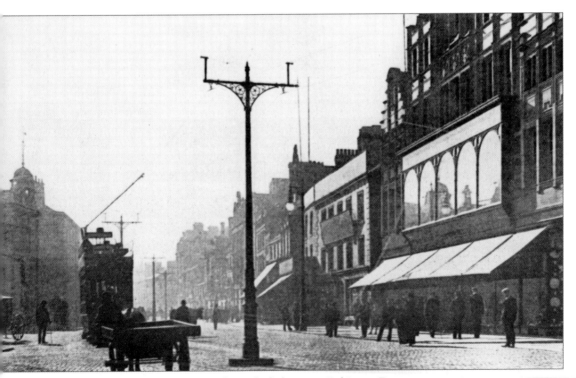

nglish Street, *c.* 1920. The large store on the right belongs to Robinson Bros.

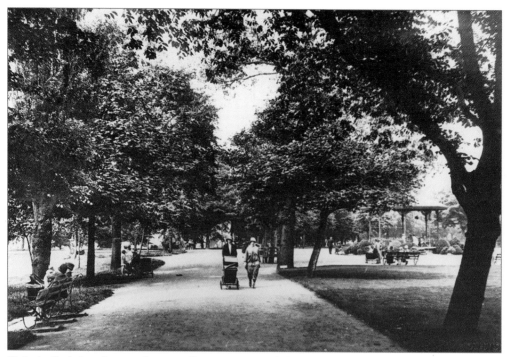

Victoria Park is a haven of tranquillity, *c.* 1925. While some stroll among the park's arboreal delights others relax near the flowerbed at the band stand. It is a delightful scene overflowing with contentment.

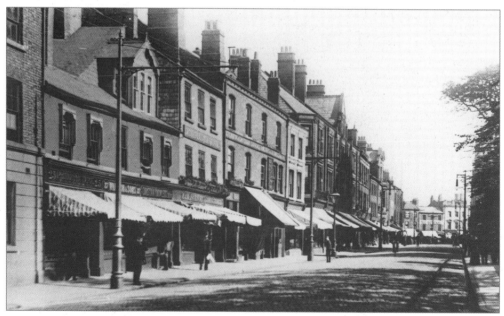

Castle Street on a sunny day, *c.* 1930. A tram is running alongside the pavement on the right and no other traffic disturbs the cyclist riding down the middle of the road. Imagine that today.

3

Carlisle's Fishing
Facilities

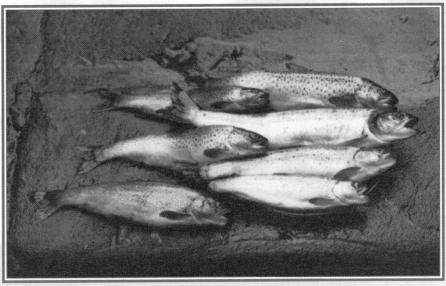

Carlisle straddles the River Eden, which, along with its tributaries, provides some wonderful fishing for salmon, brown trout, grayling and sea trout. Here is a good catch of Eden trout.

On Friday 17 December 1852, the first meeting of Carlisle Angling Association was held in the Royal Hotel Meetings of the association are still held there. But it was at King Garth House, a northern view of which shown here, that a fishing charter for Carlisle was signed. Four mayoral and corporation plaques are displayed on this wall.

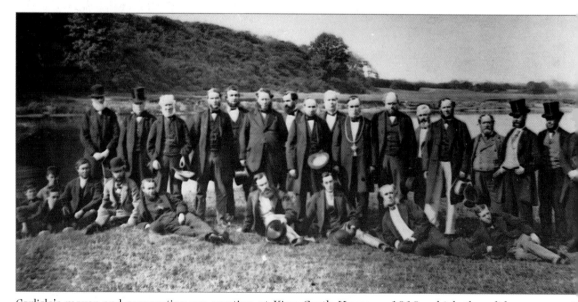

Carlisle's mayor and corporation are meeting at King Garth House, c. 1910, which they did every year in accordance with the Carlisle Fishing Charter. This was always preceded by a lavish civic breakfast at the long-gone Bush Hotel in Carlisle.

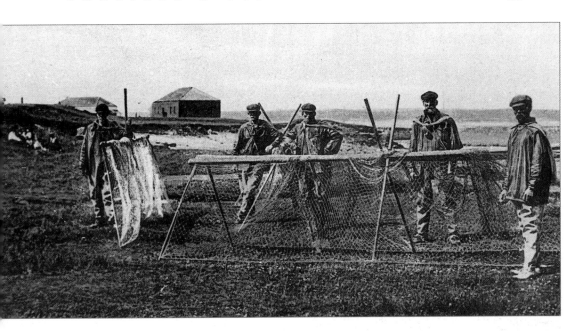

alf-net fishing is a method of catching salmon as
ey enter the River Eden from the Solway Firth
their run upstream to their spawning ground.
he salmon swim a lagoon half separated from the
a by a sand bar. Fishermen, like those here at
sher Cross in about 1910, position their half-nets
cross the salmon run and in this way a great
any, but by no means all of them, are caught.

an Templeton, with a nice catch of Caldew trout
1938, was a keen fisherman who kept notes of
is catches. He describes how, on a summer night
1934, he fished the Eden near the North
ritish Railway Bridge at Carlisle from 10 p.m.
ntil about 4 a.m. and caught a good bag of fish.
ltogether he hooked six sea trout weighing a
otal of 20lb, thirty-four hirling, which are young
ea trout, which between them weighed 20lb and
vo Eden grey trout which together weighed 6½lb.
f this typical catch he kept only a few for
imself, giving the bulk of it to the Carlisle
ifirmary kitchens.

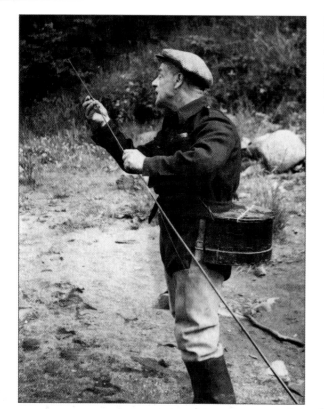

Here Dan Templeton is ready for another fishing trip, this time on the Caldew. All his Carlisle fishermen friends dressed in much the same way. The type of fly used is very important to a fly fisher. Two favourites with Dan Templeton were 'teal and silver' and 'turkey and purple'.

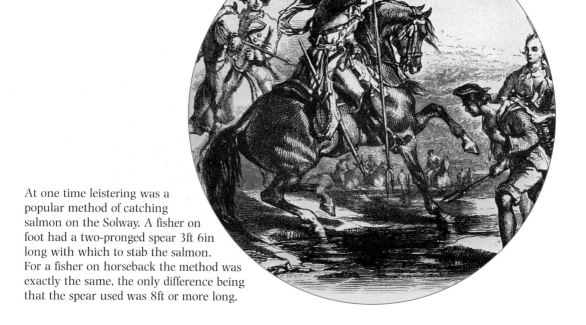

At one time leistering was a popular method of catching salmon on the Solway. A fisher on foot had a two-pronged spear 3ft 6in long with which to stab the salmon. For a fisher on horseback the method was exactly the same, the only difference being that the spear used was 8ft or more long.

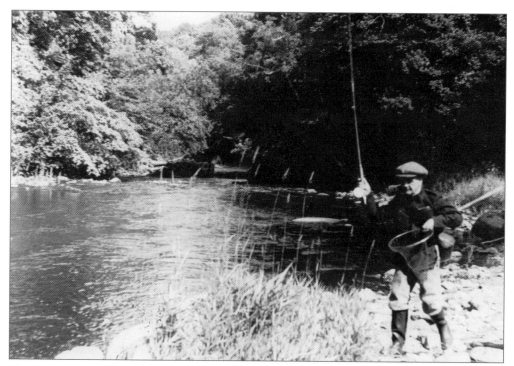

There is an eternal and timeless beauty about Carlisle's rivers that holds the key to contentment; and this is just one aspect of fishing for trout, as Dan Templeton is doing on the River Caldew above Seberham.

The gentle flow of cool water, overhung with arboreal shade, the plop of a trout rising to a fly, the soft murmur of the Caldew and all else is stillness. Gordon McDowell and Dan Templeton have before them the welcome prospect of fresh trout for supper – pure, unadulterated bliss.

Keen fisherman the late George Martin is fishing the Eden at The Bone Mill. Many visiting anglers ha
fished the same water, welcomed by Carlisle Angling Association. In 1935, for example, any visiting angl
could fish for salmon on payment of £1 1s per week. In addition, a conservator's salmon licence cost on
£3 per week. Trout permits cost 7s 6d per week plus 1s 6d for the licence. This allowed visitors to fish
miles of the River Eden at Carlisle and 5 miles of the River Caldew.

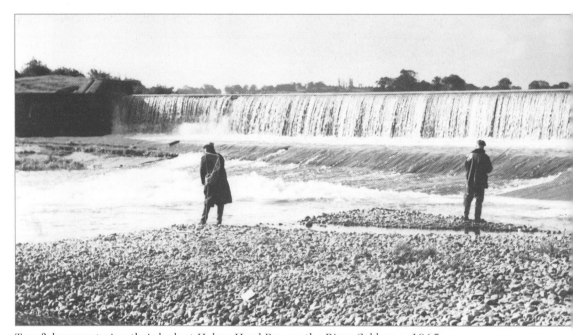

Two fishermen trying their luck at Holme Head Bay on the River Caldew, c. 1965.

hat a proud moment for James Templeton! He is
tured with a rather large salmon he caught near
e Fence End on the River Eden in 1954. The salmon
ighed a massive 42lb.

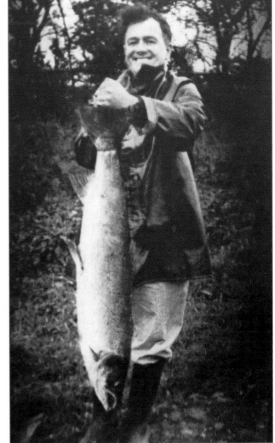

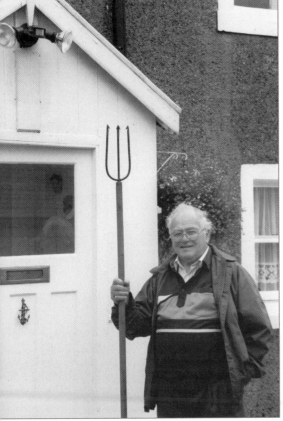

James Templeton half a century later, armed with
a long leinster of the type used by fishermen on
horseback. Anybody got a horse? This leinster has
three prongs; they are now very rare.

This fisherman on the River Caldew is most likely using a fly dressed locally by Strong's Fishing Tackle Shop, Carlisle.

The River Eden was and remains one of the best fishing rivers in England and the boat pool at Wetheral, seen here in the 1920s, was renowned for salmon fishing from the boats, a practice no longer carried out on association water. The water is controlled by Carlisle Angling Association and consists of both banks of the Eden. It includes nine salmon pools, some with quaint names. Starting upstream there are in succession Long Road, Rickerby Docks, Petteril Foot, Half Moon, Paddy's Nose, Palden Foot, Sheep Mount, North British Flat and North British Steam; the two latter names probably originated because the North British Railway was nearby.

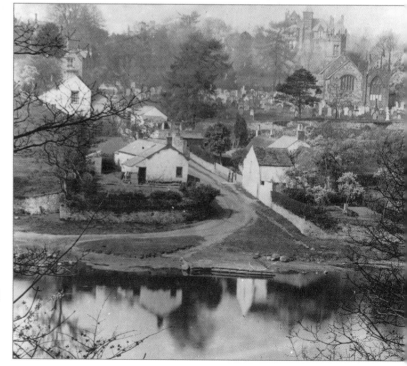

Knockupworth Gill is a favourite spot for Eden fishermen. Eden Salmon run large, 20lb being comparatively common. The average springer probably weighs in the region of 16–18lb and a good number of 30lb and a few 40lb fish are caught every year. These weights of fish are now gone. A 20lb fish is now big. The North British Railway Bridge can be seen in the distance.

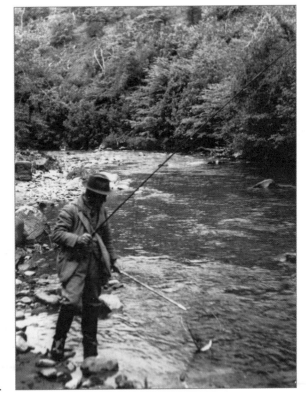

Dan Templeton netting a Caldew trout.

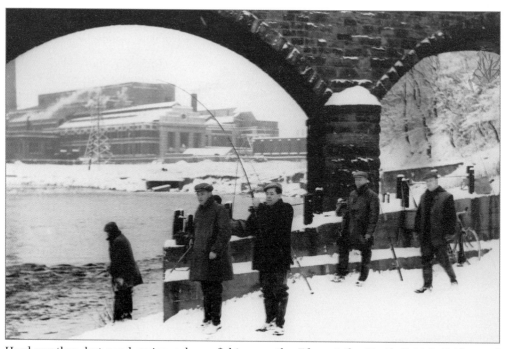

Hard weather, but good spring salmon fishing on the Eden at the North British Bridge and
Carlisle power station, now gone. A fisherman, front centre, is playing a salmon. Although
salmon are killed on the Eden in October during the autumn run, it is spring fishing that is
the great attraction. The water is mostly minnow fishing, the fly being used only occasionally,
even though fly fishing can be very successful. Floods are not really a problem to salmon
fishers. They quickly settle down and are usually run off in a day. The best-favoured gear is a
10ft spinning rod with agate or porcelain rings and a spinning wheel of the angler's choice
with a breaking strain of from 12 to 18lb and one of the following flies: Natural Sprat, Loach,
Gold and Silver Devons and the Prawn, in sizes to suit the water.

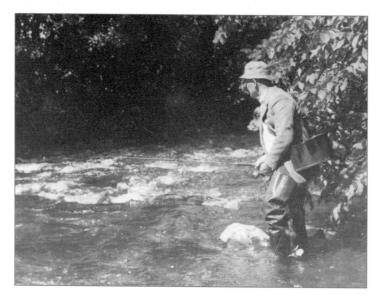

Carlisle Angling
Association water holds
very few sea trout, so it
cannot be
recommended as a sea
trout resort. But there
is plenty of sea trout
fishing from April
onwards. Here James
Templeton is fishing for
brown trout on the
River Caldew.

4

Carlisle's Hunting Links

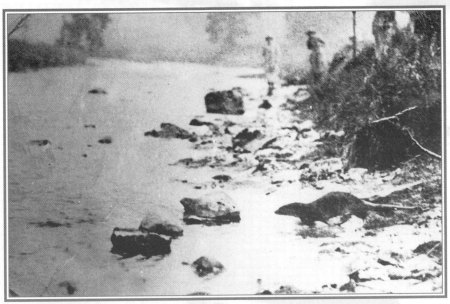

During the period Carlisle Otter Hounds were operating, they hunted the Rivers Eden, Esk, Wampod, Waver, White Lyne, Black Lyne, Caldew, Pettril, Eaumont, Cairn, Liddle and on special occasions would hold a joint meet with the Dumfriesshire Otter Hounds and hunt the Scottish rivers; and the following season the DOH would come for a joint meet on the English side.

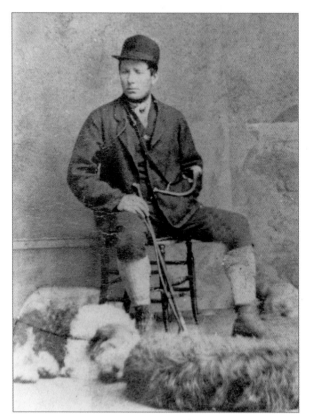

'Sandy', the first huntsman of the Carlisle Otter Hounds, which was founded in 1856.

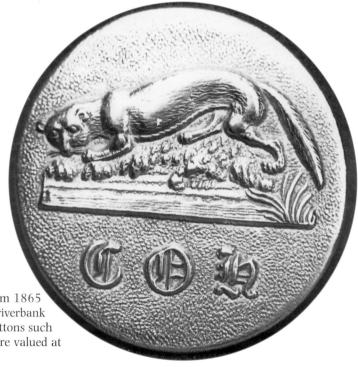

This Carlisle Otter Hounds hunt coat button dates from 1865 and depicts an otter on a riverbank above the initials COH. Buttons such as this are very rare and are valued at around £180.

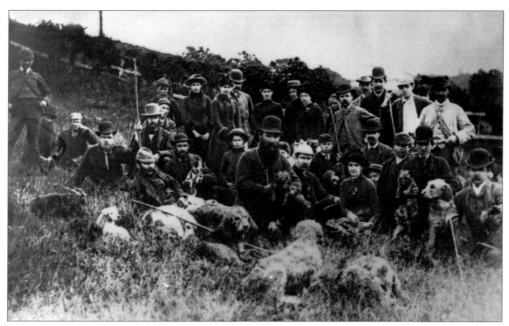

The Carlisle Otter Hounds during a hunt along the River Eden, *c.* 1880. Huntsman Tom Parker, front centre, is holding the otter. This is probably one of the oldest photographs taken of Carlisle Otter Hounds at a hunt.

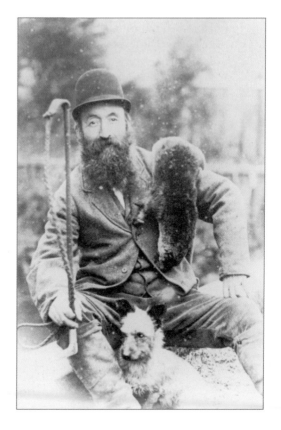

Huntsman Tom Parker, James Templeton's grandfather, *c.* 1880, with an otter on his shoulder and, sitting in front of him, his dog Wiggy. Tom Parker was the subject of a hunting song written in 1886. Called 'Tom Parker and Carlisle Otter Hounds', it had nineteen verses of which these are the first four:

From Stanwix Bank Tom Parker's horn
Peels through the morning air,
And every sportsman in Carlisle
Arises from his lair.

Down through the vale with loud halloo
Rings many a hearty cheer,
And hunters, hounds and whipper in
Pursue their fleet career.

High on the bank each hunter keen
Beholds the stirring scene,
And Belfry's voice and all the pack
Is heard at Weatheral Green.

The morning sun in burnished gold
Now tips the eastern sky
While bold Tom Parker and his hounds
Keep up the thrilling cry.

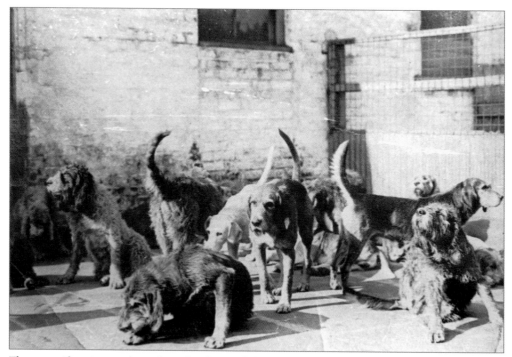

The magnificent otter hound at the front of this pack of Carlisle Otter Hounds is called Old Fireman. Otter hounds are highly intelligent creatures, chosen for their specialised abilities which, when brought together, make an efficient pack.

John Parker, huntsman with Carlisle Otter Hounds from 1897 to 1916, with the hounds at Lazonby station in 1901 at the end of a hunt along the River Eden. The hounds are worn out.

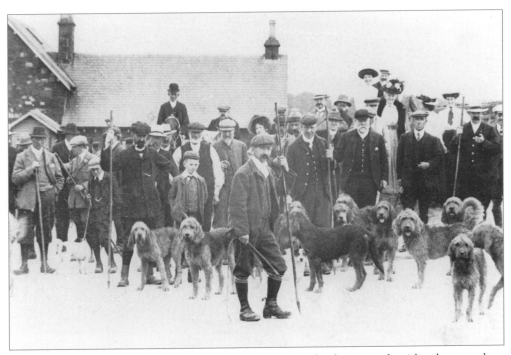

Joe Parker, huntsman of Dumfriesshire Otter Hounds, in the foreground, with other members of the hunt and the hounds. Joe was only forty-seven years old when he was accidentally killed in the Annan Kennels on 1 September 1918.

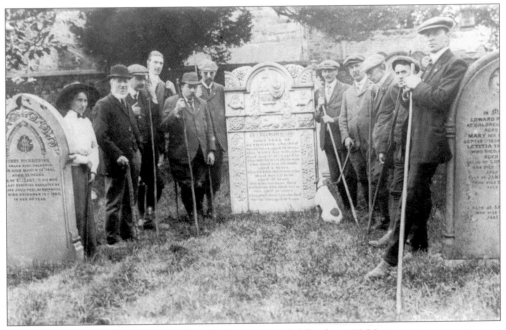

Carlisle's otter hunters gather at John Peel's grave at Coldbeck, *c.* 1920.

Having covered 9 rough miles on a Dumfriesshire otter hunt, G. Richardson, left, Billy Scott Jnr, centre, and James Templeton, right, all of Carlisle Otter Hounds, together with their hounds, *c.* 1952.

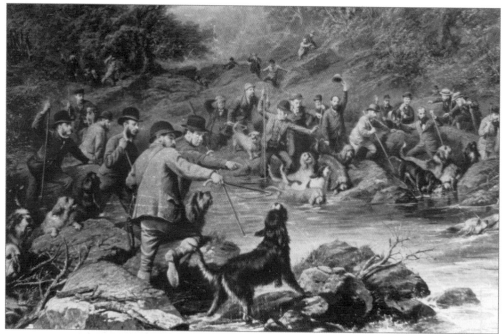

Sandy, front centre with hand out, huntsman with Carlisle Otter Hounds, hunting the River Lyne in 1860. Sandy died while following the Brampton Harriers hare hunting. Carlisle Otter Hounds stopped hunting in 1939 when the Second World War started. At that time the master was Harry Glaister and the last huntsman was Willie Hind. Otter hunting ceased in 1977.

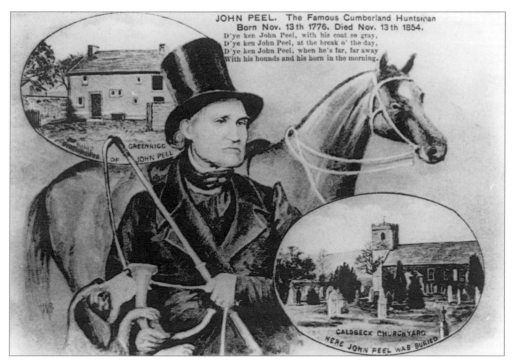

Cumberland's most famous huntsman, John Peel, who lived at Caldbeck and died on his seventy-eighth birthday.

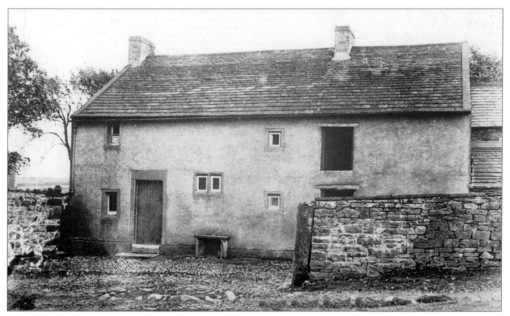

This picture of Greenrigg, Caldbeck, has the caption 'Birthplace of John Peel' but this is not correct. John Peel was born in a cottage at Park End, not far from Caldbeck, on 13 November 1776. He was about three weeks old when his parents moved to nearby Greenrigg.

These huntsmen, in the 1930s, are wearing black armbands following the recent death of sir Wilfred Lawson. Huntsman Midwinter is on the left, the other gentleman is unidentified.

Hunty Joe, 1875. Most of the country hunted by John Peel now belongs to the Blencathra Hunt. The pack hunting the north side of it is the Cumberland Foxhounds, to the west is Melbreak and to the south is the famous Ullswater pack which the renowned huntsman Joe Bowman hunted.

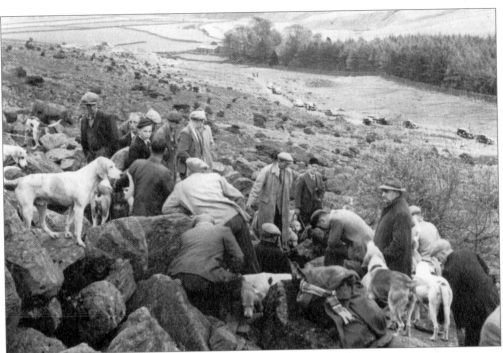

In 1903 Major Salkeld had a pack of foxhounds which hunted around Carlisle. The famous huntsman James Knox hunted with this pack. He was also a steeplechase jockey and won the Scottish Grand National. Another pack with strong Carlisle links is the fell pack, Blencathra Foxhounds, pictured here in the Mungrisdale Valley where the fox has gone to ground.

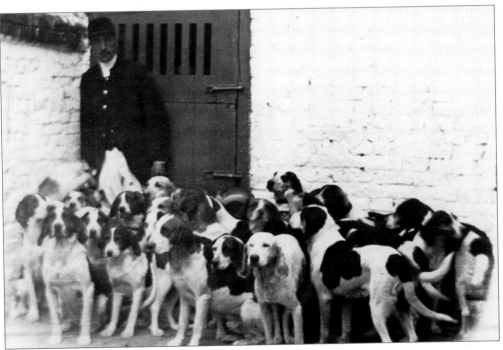

Willie Bell, huntsman of the Brampton Harriers.

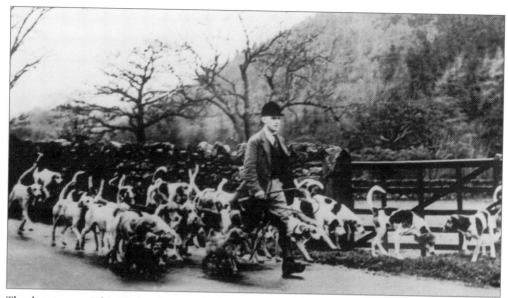

The huntsman John Richardson with the Blencathra Foxhounds, *c.* 1950. The Blencathra Foxhounds is the John Peel pack. It is a fell pack and has had seven huntsmen since 1839. No horses are used by the fell packs because of the difficult terrain. Barry Todhunter is the present huntsman of the Blencathra Foxhounds.

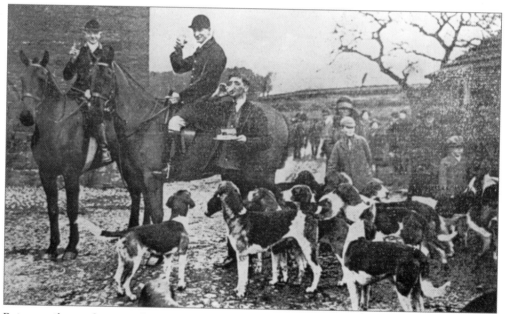

Between them, those packs of foxhounds which use horses, like the Cumberland Farmer Foxhounds, seen here with huntsman Ben Goddard, and the fell packs, which are on foot, keep the fox population under control. Eight packs that once hunted the Carlisle area have long since gone. Two packs with horses, Cumberland Farmer Foxhounds and Bewcastle Foxhounds remain, as do these six fell packs: Blencathra, Ullswater, Melbreak, Coniston, Eskdale and Ennerdale. These packs are essential to the sheep farmer in particular and farmers in general because of the destruction of sheep, lambs and poultry by foxes.

5

The Daily Round

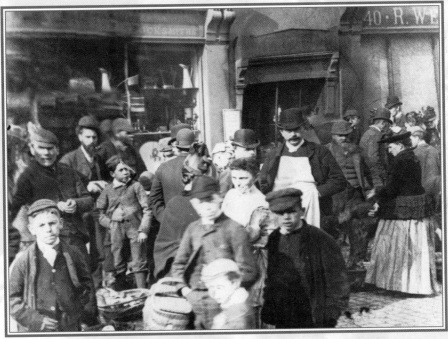

The Wednesday market in Lowther Street, *c*. 1860. During the first half of the
nineteenth century Carlisle became Cumberland's leading industrial and commercial
centre, textile production accounting for 80 per cent of the female workforce until
about 1850. Other growing businesses included Blaylock's the clockmakers. By the
turn of the twentieth century Carlisle had long been the renowned clockmaking
centre for Cumberland with more than 100 clockmakers, the most prolific of which
was Blaylock's. Other industries included William Porter, maker of fire grates and
other cast-iron goods. Dalston and Bell in Botchergate and Burgess and Hayton in
Lowther Street were also iron foundries, but by 1850 Porter's was the main one;
Porter's also supplied bricks to the Admiralty dockyards at Chatham, among others.
With more people being attracted to Carlisle in search of work,
a weekly street market was established.

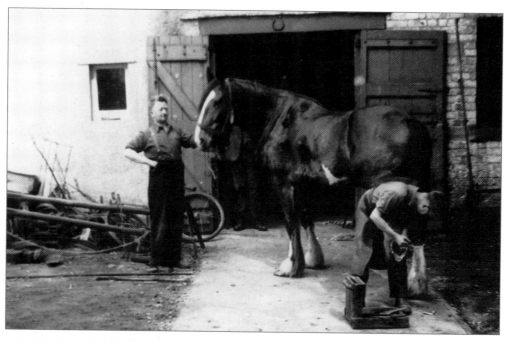

The Nicholson Brothers shoeing a horse at their smithy at Kirkandrews-on-Eden. There is a headstone to the village blacksmith at Kirklinton, near Carlisle which carries this epitaph:

My sledging hammer lies reclined,
My bellows, too, have lost their wind,
My fire extinct, my forge decayed,
And in the dust my vice is laid.
My coals are spent
My iron's gone,
My nails are driven,
My work is done.

The Village Blacksmith.

LONGFELLOW.

And children coming home from school
Look in at the open door,
They love to see the flaming forge,
And hear the bellows roar,
And catch the burning sparks that fly
Like chaff from a threshing floor.

Above the verse on the Kirklinton headstone an anvil, pincers and a hammer are depicted. Together with part of Longfellow's evocative poem, 'The Village Blacksmith', a more comprehensive collection of blacksmith's tools is seen.

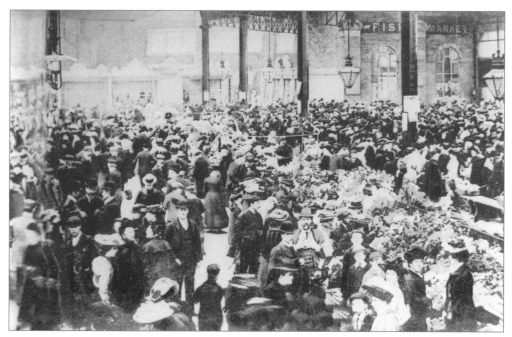

Carlisle's new covered market, which included a fish market, in 1902, the year that it was opened. It quickly proved popular.

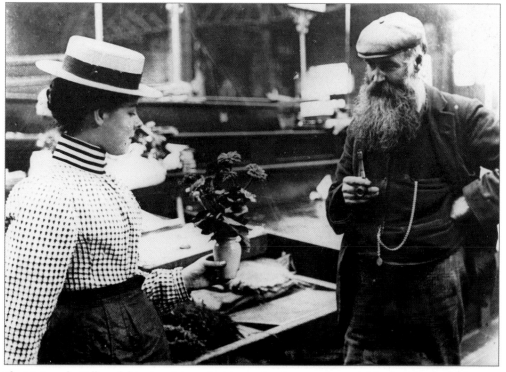

Florist Joseph Bell and his daughter admiring a lovely geranium at his stall in Carlisle's new indoor market. The geranium is in a vase or vause, depending on how haughty your culture is.

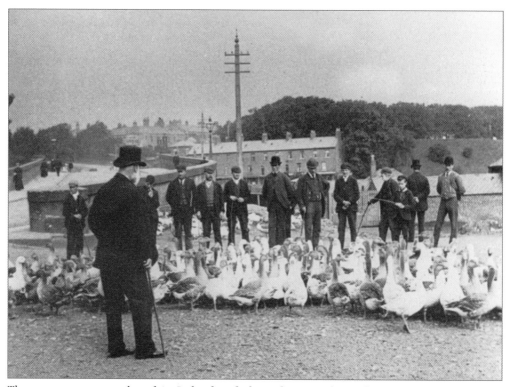

These geese were purchased in Ireland and shipped across the Irish Sea to Silloth, *c.* 1905. Then they were walked to Carlisle market for sale to the general public. During their walk from Silloth to Carlisle, their feet were protected by being coated with tar.

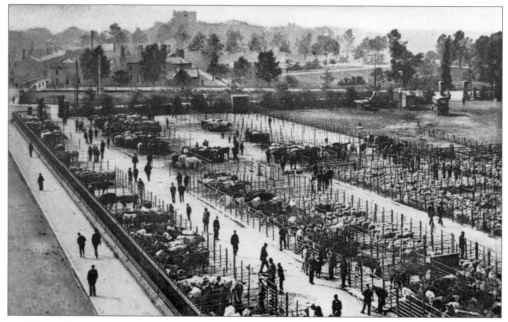

Carlisle cattle market, seen in about 1910, was the largest cattle mart in the North of England.

This picture of Carlisle cattle market, also *c*. 1910, shows its proximity to the River Eden, on the sands with Eden Bridge in the background.

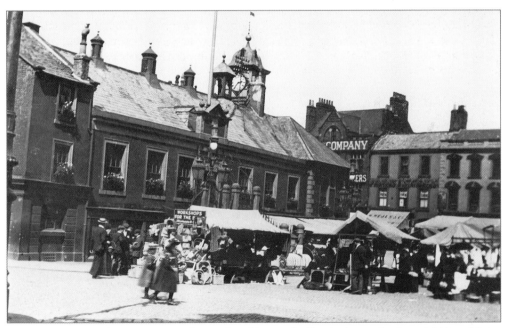

Carlisle's open market, *c*. 1910. It fronts the old town hall, which was built in 1669 and later extended. The square belfry was added in 1881. In the same year, Upperby Cemetery came into being. In 1882, public telephones were first introduced into Carlisle. The following year Carlisle Grammar School moved to better premises in Swifts Lane and in 1884 the High School for Girls opened at 19 Castle Street. Also in 1884 a fire station was built in Junction Street. In 1885 the first Special Night Mail train ran from Euston to Carlisle, the journey taking 7½ hours. The modern city of Carlisle was beginning to emerge.

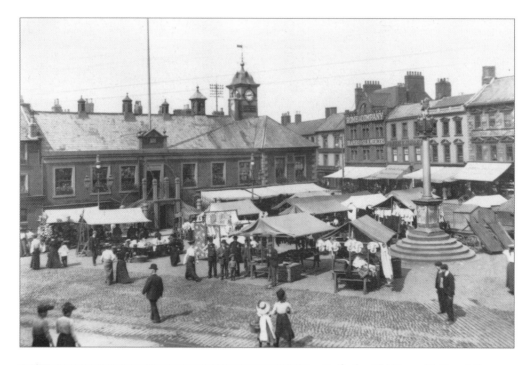

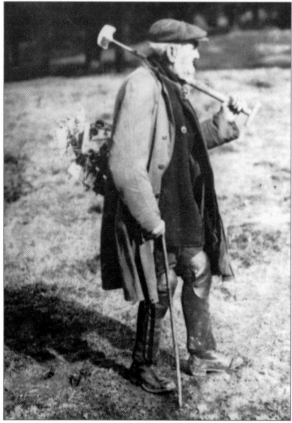

Both the Old Town Hall and the Market Cross are prominent in this view of the open market, *c.* 1920. The Market Cross, also known as the Carlisle Cross, stands where, in Roman times, several major roads intersected. A market was held on Wednesdays and Saturdays in the space occupied by the stalls and spreading forward beyond the camera. The area was called the Greenmarket and vegetables were sold there.

Mole catcher Hiram Watson of Plumpton, *c.* 1930, had the job of keeping moles in the Carlisle area under control. All the moles he caught were killed and strung up on a convenient wire fence.

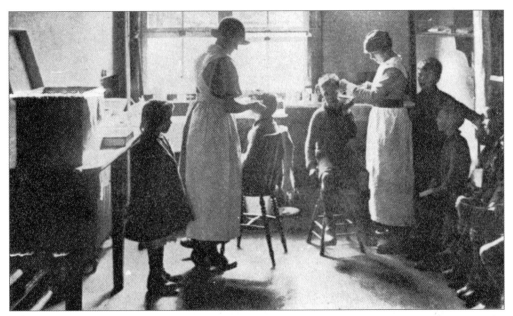

Children of George Street School, Carlisle, are shown here being inspected for lice during the 1930s. This was standard practice throughout the country at that time.

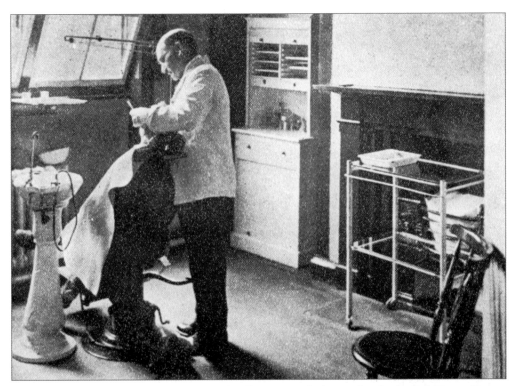

During the 1930s school dentists periodically inspected the teeth of schoolchildren. Here a pupil at George Street School is having dental treatment. When school dentists die their headstones should carry the inscription: 'Here lies so and so, dentist, filling his last cavity.'

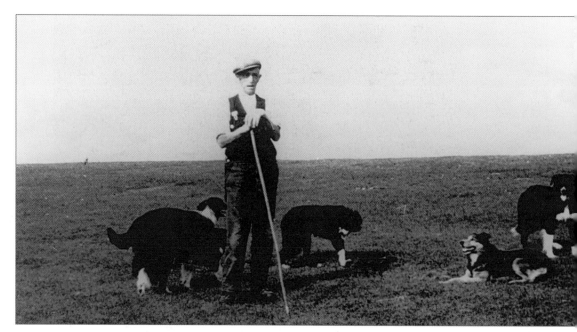

Tom Ewart was the shepherd of the Solway Marshes during the 1950s. He was very skilled at his job and worked six dogs, border collies, four of which are seen here with him near Burgh-by-Sands.

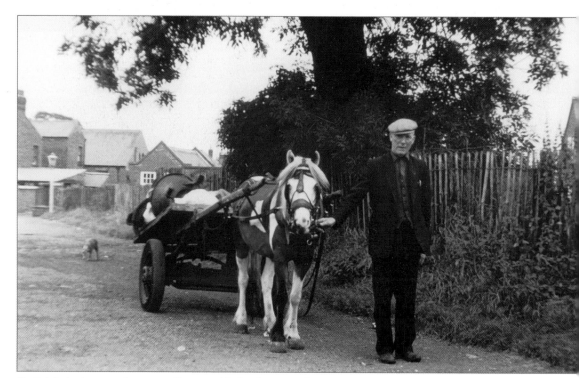

Carlisle's last rag and scrap collector with his horse and cart, in 1965. He was a gentle, most likeable man a real gentleman, the likes of which, sadly, are almost as rare as hen's teeth. Many people think that angel are dressed all in white and have wings; but some wear dark suits and flat caps.

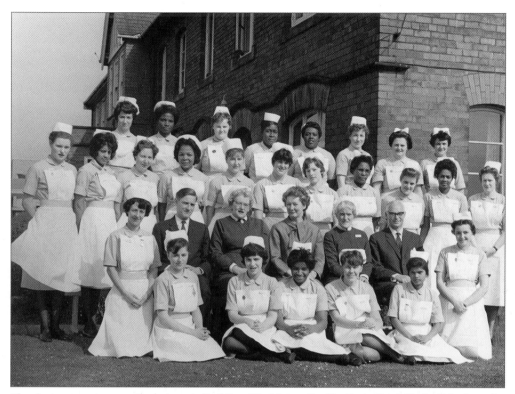

The doctors, matron and nursing staff of the City Maternity Hospital, Fusehill, Carlisle. Into the capable hands of these dedicated people are Carlisle's new arrivals entrusted. They are called babies and are tiny bundles with a loud noise at one end and a complete lack of responsibility at the other.

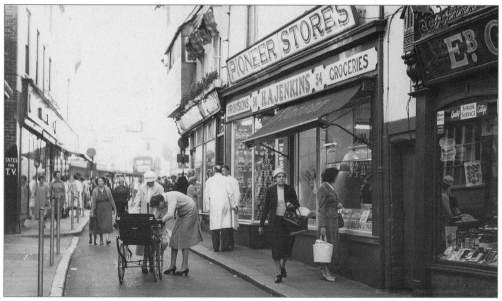

Shoppers outside the Pioneer Stores in Fisher Street, *c.* 1970. Mr Jenkins, in white with his back to the camera, owns the grocery store. His brother had a meat shop, now Pioneer Meat.

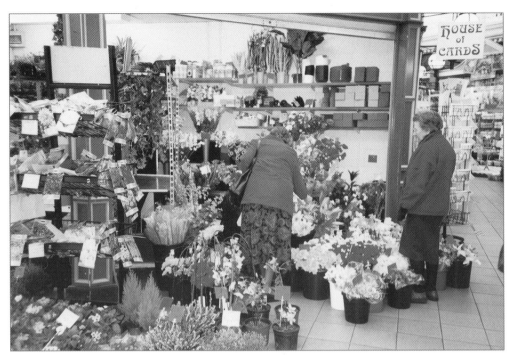

A flower stall like this one in Carlisle's covered market, *c.* 2003, had no part in the original market when it opened in 1902.

The stalls in Carlisle's open market in 2003 offer a much greater variety of produce than they did in 1910. The modern shoppers are dressed more casually than in the early days of the market; but one aspect of shopping has not changed: the search for a bargain.

6

Carlisle Capers

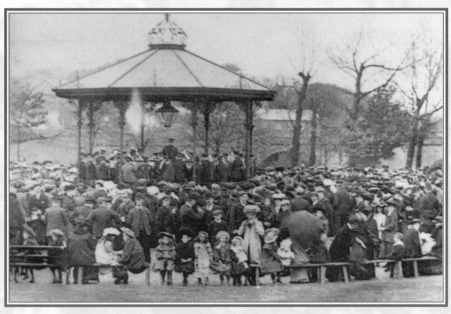

There is nothing like a stirring Sousa march to stir the blood, and the music being
played by South Shields Salvation Army Band, in a Carlisle park on Whit Monday
1907, may be nothing like a stirring Sousa March. But the band is playing
something melodious enough to hold the attention of an appreciative crowd of
music lovers. It all adds to the holiday atmosphere; and Carlisle folk know how to
enjoy themselves.

Cumberland and Westmorland wrestling is the art of 'takking hod'. Working with Hardwick sheep, wading waist deep among a group of them, catching one horn, bending down and lifting the sheep over his shoulder is good trainin for C&W wrestling. A man who can easily lift a sheep from one pen to another at an auction mart is mentally and physically prepared to tackle a man weighing between 9 an 12 stone. Where many a man would 'rive hissen i' bits' (tea himself to pieces) lifting a sheep, a C&W wrestler would make use of his opponent's strength and movements. A goc C&W wrestler is an opportunist. The contestants drawn her are evenly matched physically, but smaller men often tackle larger contestants and frequently win.

Cumberland and Westmorland wrestling is probably the cleanest of the four main English wrestling styles, and despite the attraction of increasing cash prizes has maintained its freshness. Yet there are frequent 'barneys' among the spectators when local sentiments are strongly in favour of the local contestant. Spectators at the Carlisle ring would often vociferously object to the way one or other of the contestants was thrown. 'They're gan to ressel fair' (They are going to wrestle fairly), was the usual exhortation from the 'specs'. This is a list of winners of all weights from 1809 to 1876. It shows that the honours are evenly spread

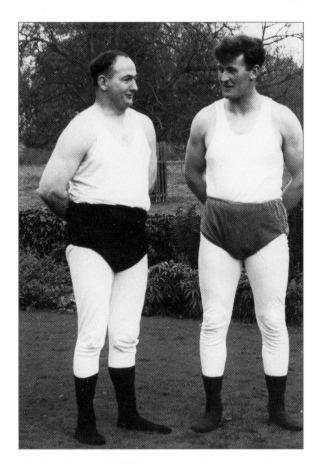

C&W champion wrestlers Tommy Little, left, and Ted Dunglinson 'weighing each other up' prior to a contest.

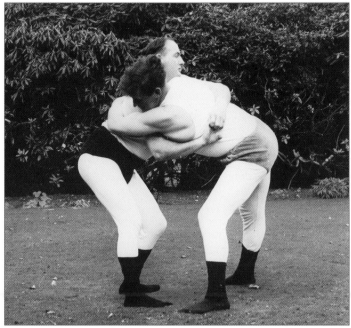

Now the champions come to grips, demonstrating the art of 'takking hod'.

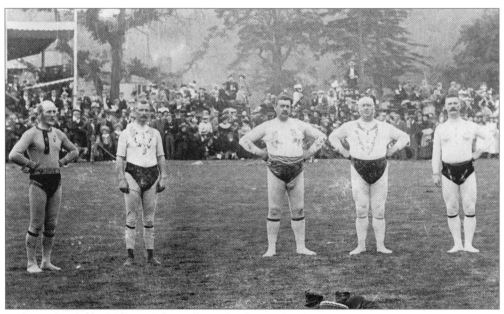

C&W heavyweights wrestling at Grasmere sports, 1907. The judges were Lord Lonsdale and Sir Wilfred Lawson.

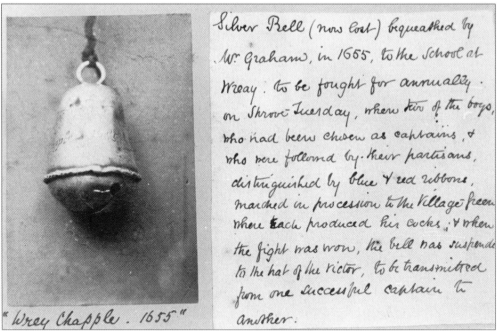

"Wrey Chapple . 1655"

Silver Bell (now lost) bequeathed by Mr. Graham, in 1655, to the School at Wreay: to be fought for annually on Shrove Tuesday, when two of the boys, who had been chosen as captains, & who were followed by their partisans, distinguished by blue & red ribbons, marched in procession to the Village green where each produced his cocks; & when the fight was won, the bell was suspended to the hat of the victor, to be transmitted from one successful captain to another.

There was no set time for cockfighting in the Carlisle area. It took place at all times of day and sometimes at night. It was particularly popular around Shrove Tuesday and Easter, and was indulged in by schoolboys as well as adults. Indeed, it was a regular annual event at several local grammar schools. At Wreay School the cockfight was held on Shrove Tuesday, the schoolboy owner of the winning cock being presented with a small silver bell, pictured here. For the following year the winning boy owner wore this bell in his hat. This practice ceased in 1728 when the silver bell was stolen.

Some cock-pits were found near a church and sometimes in the churchyard itself; and cock-fights or matches were often held on Sundays. The cock-pit at Carlisle was centrally sited in one of the courts off Lowther Street. It was built by the Duke of Norfolk and Sir James Lowther in 1785. It was later used as a brass foundry and a blacksmith's shop, and was pulled down in 1876. At some cockfights the cocks wore steel spurs which, in many cases, could prove fatal. Some spurs are on display in Carlisle's museum.

In 1919 the predominant sentiment in Carlisle was that the war to end all wars had been won and that the time had come to celebrate this achievement. So a street party was held at William Street, Botchergate.

The charming young lady in a crinoline is not in a time warp. She is taking an active part in Carlisle's Great Fair of 1976, dressed for the part, enjoying herself and stealing the picture.

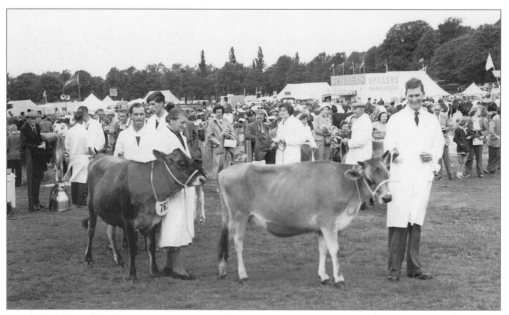

For many years Bitts Park, seen here in 1960, was home to the Cumberland Show. Exhibiting high-quality beasts has always been the lynch pin of this very popular crowd puller. The Cumberland Show is always a large attraction for the surrounding farming community, continuing to attract large crowds to its new home, Carlisle's Rickerby Park.

An article, 'The Natives of Carlisle', which appeared in the monthly periodical, *The Citizen*, on 1 May 1830, said that Carlisle people 'are neither English, Irish or Scotch, but a mongrel breed between the three – incapable of friendship'. The author of the article, not to put too fine a point on it, was nuts. It was to bulls, such as the one seen here behind the delightful girls at Cumberland Show in 1970 that he referred. Carlisle folk are the very antithesis of his completely false observations.

Breeding fine English game cocks had long been a popular hobby in the Carlisle area, great pride being taken in rearing them.

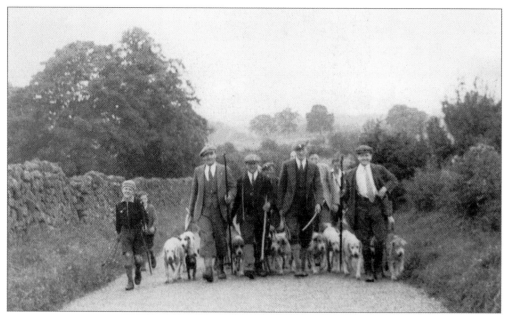

For every breeder of English game cocks there were at least ten Carlisle men who followed the otter hounds. Here Carlisle Otter Hounds are on the way home after a long hunt (17 miles) in 1937. The otter hunters are (left to right) Tom Ullyhart, W. Hird, huntsman, Jerry Lawson and James Templeton. They left the kennels at Canal Bank, Carlisle, at 4.30 a.m. for the meet at West Linton Bridge at 7 a.m. They arrived back at the kennels at 8.40 p.m. at the end of a very long day.

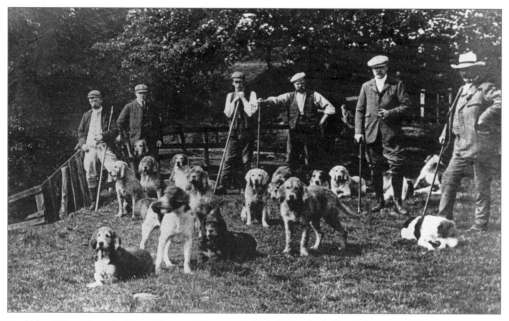

Carlisle Otter Hounds in peak condition, *c*. 1910. The dark hound sitting front centre was called Old Fireman and won many awards at dog shows. John Parker, huntsman, is on the left. Mr W. Amos, a Carlisle grocer, is second on the right.

Carlisle market day is always a big attraction, and is normally held on a Wednesday. The duck and poultry market, *c.* 1900, is on the east side of Lowther Street and farm folk sell butter, eggs and the like on the west side.

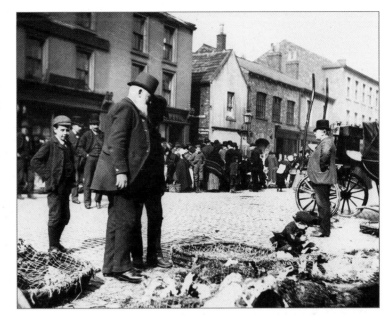

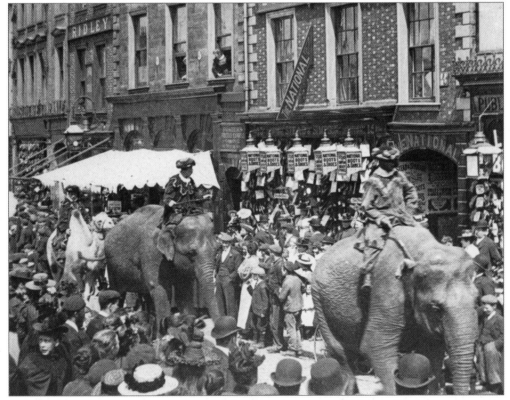

Now and again the circus would come to Carlisle; and this would be a talking point for weeks before and after its arrival. Two elephants and a camel are moving along English Street, which is packed with spectators, in 1888. In the days before television, a circus with exotic animals brought a glimpse of excitement into dull, urban lives throughout the country.

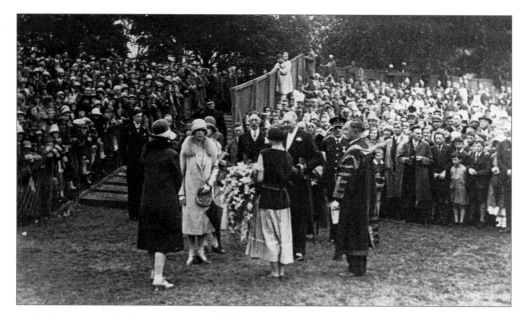

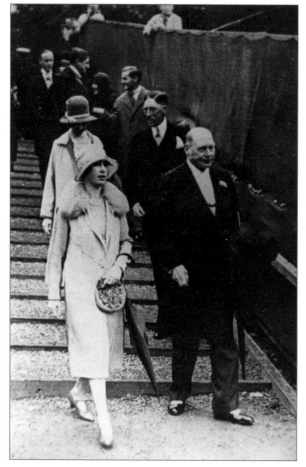

Lord Lonsdale, the Yellow Earl, is pictured here at Carlisle's historical pageant in 1928. He always wore a yellow buttonhole, a gardenia or a rose. With him are the Mayor of Carlisle and dignitaries at the opening.

Carlisle's historical pageant lasted from 6 to 11 August 1928, and a different person opened it each day. Monday: The Right Hon the Earl of Lonsdale GCVO; Tuesday: Theodore Carr Esq., CBE, JP; Wednesday; The Right Hon J.H. Thomas PC, MP; Thursday: The Worshipful the Mayor of Carlisle, Cllr J.H. Henderson JP; Friday: The Right Revd The Lord Bishop of Carlisle; Saturday: HRH Princess Mary (Viscountess Lascelles). Princess Mary is seen here at the opening of the Historical Pageant on 11 August 1928.

7

The 'Jew' of Carlisle & Romany

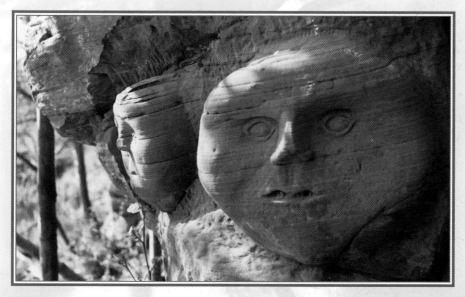

In 1763, George Mounsey started a firm of calico printers. His other firm was Mounsey & Giles, solicitors. It was into this family that William Henry Mounsey was born in 1808. As a boy, he showed a fondness for strange and obscure things, which became an obsession. He was a brilliant scholar with an enquiring mind and a penchant for languages. At seventeen, he purchased a commission in the 20th (Cambridgeshire) Regiment, and spent much of his military service in the Middle East where he met many Jews. He studied their way of life, history and religion. In 1844 he left the army and became a solicitor in the family business. This gave him the time and money he needed to pursue his interest in the enigmatic. Remembering his experiences in the Middle East, he began to dress and act like a Jew, a part he played so well that he became known as the 'Jew' of Carlisle. He took to chiselling strange faces and puzzles in the soft local sandstone. So well hidden were William Mounsey's works that, even today, many locals have never seen them. These are some of his stone heads near Armathwaite.

Although William Mounsey is perpetuated in his strange rock carvings, it is for his famous journey from the salt marshes of the Solway in search of the source of the Eden and what followed that he is best remembered. Having walked the full length of this beautiful river he reached his destination at lonely Black Fell Moss on the Ides of March (15 March) 1850. This is part of his route near Armathwaite.

To mark his achievement, Mounsey built a special monument, the Jew Stone; prominently displayed on it was the Star of David. The Jew Stone measured 7ft by 7¼in by 3in and was made of a limestone called Dent Marble. It was inscribed with sigils and texts in Latin and Greek. The Latin was straightforward and read: 'William Mounsey, a lone traveller, having commenced his journey at the mouth and finished at the source, fulfilled his vow to the genius and nymphs of the Eden on the 15th March, 1850.' In the original Latin, Mounsey's name was Latinised and back to front. This is an exact replica of the original Jew Stone.

The Greek inscription read: 'Seek the river of the soul – whence it springs, when thou hast served the body in a certain order – when thou has acknowledged thy duty to the sacred Scriptures – thou shalt be raised again to the order from which thou art fallen. Let us flee with ships to our dear native land; for we have a country from which we have come and our Father is there.' The Stone also contained two symbols. One was a T repeated three times with the foot of each T interlocking. A T represents the TAU occult sigil in the earliest form of a cross; and repeated three times with the Ts touching becomes the Holy Trinity. The other symbol was the Seal of Solomon. The river that joined William Mounsey to them was his beloved Ituna, the Eden, seen here downstream of Armathwaite; a falcon was nesting on the clearly seen bluff.

For twenty years the Jew Stone stood in splendid isolation on the northern rim of Red Gill overlooking Eden's source. Then, in 1870, during the building of the Settle–Carlisle Railway line, a camp was established at Aisgill for the construction workers. Some of the navvies came across the Jew Stone and, in an act of vandalism, smashed it, leaving it in five roughly even parts. There it lay, broken and forgotten by most, until long after the Second World War, close to, but just out of shot of Lady Anne's Pillar, seen here close to the Eden's source. Charlie Emett is on the left.

After fleeing from the Nazis in Poland, Shalom Hermon joined the Jewish Brigade of the British Army. In 1945, while an officer at Catterick Camp, he saw the name 'Jew Stone' on a map and his curiosity was aroused. Thirty-nine years were to pass before that curiosity was satiated, during which time the handsome officer had become the Israeli Minister for Physical Culture. In 1984, while on an Israeli mission, and after much research into the Jew Stone, Shalom and his lovely wife Dvora called at Hanging Lund, near the Eden's source, and made themselves known to the Thompsons, where he was shown the pieces of the broken stone. Shalom assured his hosts that the Jew Stone did have very strong Israeli connections. Shalom is seen here, left, at Hanging Lund with the Thompsons.

Shalom with Dvora in 1989. He said that despite William Mounsey being a gentile, he, Shalom, would try and raise some cash, hopefully to mend the Jew Stone. Meanwhile Mary Thompson checked with local stonemasons about the feasibility of repairs and was told that the stone could not be mended. A replacement would cost about £500. There was no money in the bank. Shalom, in Jerusalem, was informed. Then, suddenly, the correspondence stopped because, sadly, in June 1985, Mary Thompson died. Here the matter of the Jew Stone rested.

Since childhood Charlie Emett had known about the Jew Stone and had tried, without success, to find it. He included his thoughts on it in a book on Westmorland and W.R. Mitchell, then editor of *Cumbria* asked: 'Dare we hope that it [the Jew Stone] will soon be returned to Eden's source?' It was a significant question for, as a direct consequence, Charlie Emett asked Guy Thompson if he could give any practical help. After all, the Jew Stone had bugged him for most of his life and, like William Mounsey, he had been befriended by Jews while abroad and felt a strong affinity towards them. With the broken Jew Stone at their feet, half a dozen enthusiasts weigh up the problem.

A possible solution is reached: Charlie Emett will retrace William Mounsey's journey, hopefully to raise enough cash to produce a monument worthy of the memory of the 'Jew' of Carlisle.

On Good Friday 1986, under a bruised sky, Charlie Emett and friend Stuart Dean walked the length of the Eden, sponsored, with staunch friend Ken Hudson as back-up. It took them three days, following William Mounsey's footsteps as closely as they could. Here Charlie Emett is passing Warcop Bridge, the only bridge across the Eden to withstand the great flood of 1822. A vast snowdrift covered the Eden's source on Black Fell Moss and icicles hung from peat overhangs when the walkers reached their destination. It was exactly 6 p.m. on Easter Sunday. They had achieved their objective.

The walk raised £200, short of their target but a base on which to build. A Jew Stone account was opened with a shortfall of £300. Floods of letters followed. Shalom, fundraising in Jerusalem, was kept informed of developments. More local fundraising brought in £100 and Shalom collected £200, which he donated to the Jew Stone account on his next visit to England. He is seen here (right) shaking hands with Giles Thompson, Guy Thompson's son, having handed over his £200, watched by Charlie Emett at Pendragon Castle.

On 14 July 1988 an order was placed with stonemason Parkin Ness for a replacement Jew Stone. Within a week they had a problem; one word, *Muryesnuom*, did not seem to fit. Could anyone help? Fortunately someone could. The word was Mounsey, reversed and Latinised. The unveiling of the new Jew Stone was to take place at 2 p.m. on 21 September 1988, when Shalom and Dvora would be in England. As they unveiled the stone, Shalom, in his speech, said, 'In Hebrew Shalom means "peace" and Emett means "truth". It seems very appropriate that Jew and gentile have come together to do this thing in peace and truth.' Here two interested spectators, Irvine Johnstone and Giles Thompson, admire the Jew Stone, which was erected on Outhgill village green to reduce the risk of vandalism.

The ceremony was covered by Border Television and the *Cumberland & Westmorland Herald*. It was rounded off with drinks at the Black Bull, Nateby. Financially, the venture broke even. So it came about that William Mounsey, the 'Jew' of Carlisle, created a strong and lasting bond between Jew and gentile, which is what he wanted.

The Revd George Bramwell Evens, 'Romany' of the BBC, was a brilliant communicator who had the ability to show people the glory of God through the wonder of nature. He laced his sermons with words that came straight from the heart of a gypsy. To him, religion was a very practical thing. He was born in Hull in 1884, son of a gorgio (non-gypsy) father and a Romanichais (gypsy woman). As a young man he entered the Methodist Ministry and in September 1914 moved to Carlisle as minister of a small Methodist chapel. He was not accepted for military service because of a heart murmur. When a munitions factory was built around Gretna, he worked among the navvies and organised a club for them. Because of this work, he was invited to stay in Carlisle as minister of the main Methodist chapel in Fisher Street.

The Methodist chapel was a condemned building. A new one would cost thousands and the congregation was not wealthy. Flour miller Joseph Rank, who never supported chapels, offered to donate £10,000 towards the cost of a new mission hall (£26,000). Evens and an architect designed a hall that could serve as a chapel and accepted the £10,000. Evens had the debt reduced to £10,000 by the time the building was opened on 12 April 1923, with Joseph Rank doing the honours. There was to be a collection, which Rank had promised to double; and this gave Evens an idea. Sitting on the platform with Rank and other officials, he announced the subscriptions received during the previous month and asked, 'May I add them to today's collection?' The audience roared with laughter when Joseph Rank smiled and nodded approval; and the new chapel opened free of debt. When possible the Revd Evens liked nothing better than to visit his friends, the Potters, at Old Parks Farm, and to swap his ministerial suit for gypsy clothing. He could relax at the farm in his vardo, which was pulled by his horse, Comma, so called because it seldom came to a full stop.

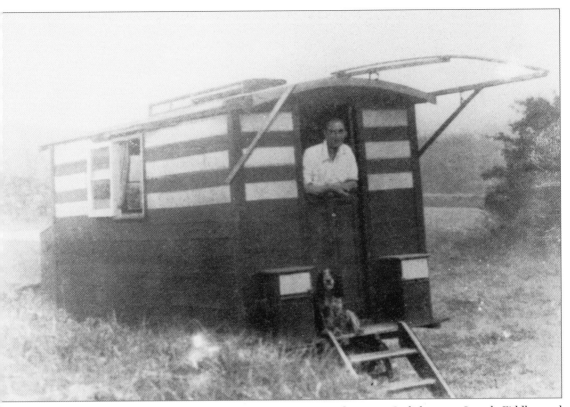

he Revd Bramwell Evens considered himself a good fisherman, but two Carlisle men, Joseph Fiddler and
hn Rudd, showed him otherwise. The three developed a firm and lasting friendship and they called him
ram, a familiarity used only by his wife, Eunice, and close friends. Since much of Evens' time was spent
ading and writing, his fishing expeditions along the Eden were very precious to him. He also loved
xploring the quiet lanes of the Eden Valley in his vardo, with Raq, his faithful cocker spaniel, at his side.
hroughout his life he had several cocker spaniels, all called Raq.

or more than twenty years Old
arks Farm became the retreat of
he Revd Bramwell Evens; and the
ospitality extended by the highly
espected Potter family went far
eeper than usual. Whenever he
eeded rest and solitude the
inister retreated to the farm and
ecame Bram, the beloved
agabond who found peace and
ontentment sitting in his vardo
eeling spuds.

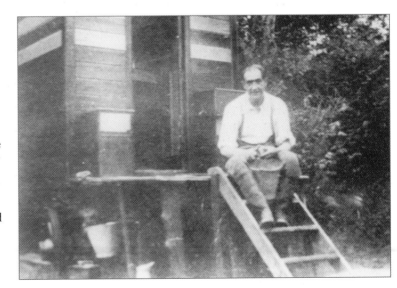

One day, when Evens was walking down Market Street, Manchester, a stranger approached him and asked, 'you've done some broadcasting, haven't you?' Bramwell Evens said he had. The man, who never disclosed his name, mentioned their conversation to Olive Schill of *Children's Hour*. Within a month the minister was engaged to take part in this popular programme. Not wanting to be called 'Uncle', on the spur of the moment he said, 'call me Romany', and soon Romany took precedence over Bramwell Evens. Only his daughter disapproved of his new title, for she had been christened Romany June and felt she had a prior claim to it. Romany had a five-minute spot for several months before being given more air time. His programmes began with 'Once again we take you out with Romany . . .' and much of the authenticity of *Out with Romany* came from his involvement with the beautiful Eden Valley. Asked to select a signature tune he had no hesitation in choosing 'Lullaby of the Leaves'. Romany had been broadcasting for five years when he was asked to write a book for children. His first was an immediate success; and while he wrote, he broadcast. The then editors of *The Listener* summed up the ideal broadcaster as one who has sympathy, simplicity and freshness. Romany, seen here at his log fire, had all of these qualities.

In June 1942 radio critic Herbert Farjeon praised *Out with Romany*, calling it 'the BBC's best creation'. Romany loved quiet places like the one shown here where his wife, Eunice, and his vardo are resting. His favourite spot was Old Parks Farm, overlooking his beloved Daleraven Beck. On his last visit to the farm with Eunice he climbed a grassy bank overlooking the wooded ghyll, sighed contentedly, turned to her and said, 'This will do for me. When I die I'd like you to scatter my ashes here.' Within a month she was carrying out his wishes. Now a bird table set inside protective railings carries this inscription: 'Sacred to the memory of Rev. Bramwell Evens, Romany of the BBC, whose ashes are scattered here. Born 1884. Died 20th November, 1943. He loved birds and trees and flowers and the wind on the heath.'

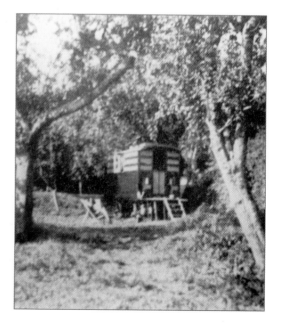

8

Cumberland Characters

Of all Cumberland's huntsmen, the most famous is John Peel
who was born on 13 November 1776, not at Greenrigg,
Caldbeck, as is generally supposed, but in a cottage at
Park End. It was there that John Peel, sketched here by
Joseph Simpson, spent his childhood and youth.

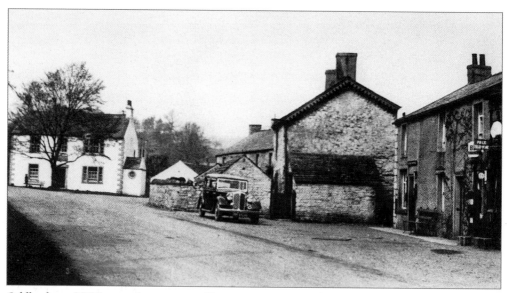

Caldbeck, *c.* 1950, was the nearest village to Greenrigg, where life on the farm was hard. It was a combination of hard living, hard work and hard weather that contributed to making John Peel an outstanding huntsman. He worked hard and was well used to handling horses.

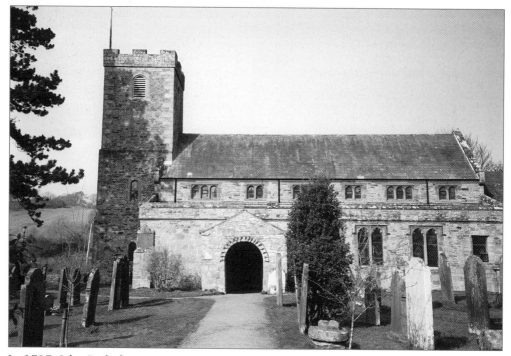

In 1797, John Peel, then twenty-one years old, fell in love with Mary White, aged seventeen, daughter of an Uldale farmer. The banns were read out in Caldbeck church (above), but Mrs White opposed the union because of their youth. So John carried Mary off. They made a midnight escape from Mary's bedroom window and rode off on Binsey, his father's fastest horse, to Gretna Green, where they were married.

ary White's parents eventually approved of the marriage, which was solemnised in Caldbeck church on
) December 1797. Soon after the wedding John and Mary Peel moved to Ruckwaite village where they
ed for a while. Their home was the house near the tree, and they also kennelled John's hounds there.

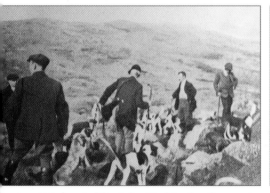 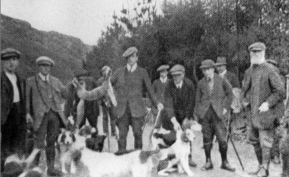

e country hunted by John Peel is, for the most part, covered by the Blencathra Hunt, a fell pack with all
e hunting done on foot. These pictures, dated November 1919, show the only possible results of a day's
nt: either the fox goes to ground or it is killed.

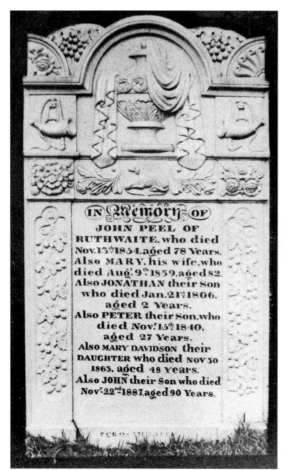

John Peel died on 13 November 1854, the very day on which he had been born seventy-eight years earlier. He shares his grave with his wife Mary, and their daughter and three sons, as his headstone shows.

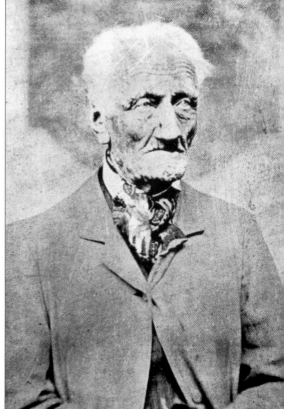

John Peel was a famous huntsman, but so were many others like James Knox, who was also a steeplechase jockey and won the Scottish Grand National. John Peel is remembered not so much for his hunting ability but because a friend of his, John Woodcock Graves, whose portrait is shown here, wrote the words to 'D'ye Ken John Peel?' Later, William Metcalfe (1830–1909) put the words to music. In his early days he was a chorister at Norwich and later a lay-clerk at Carlisle Cathedral for fifty years. 'D'ye Ken John Peel?' became the Regimental March of the Border Regiment, now the King's Own Royal Border Regiment.

An oil painting of Tom Parker, famed huntsman of the Carlisle Otter Hounds, in 1880. The Carlisle Otter Hounds hunted eleven English rivers and occasionally Scottish rivers with the Dumfriesshire Hunt. Tom Parker, grandfather of James Templeton, is buried in the old churchyard, Brampton.

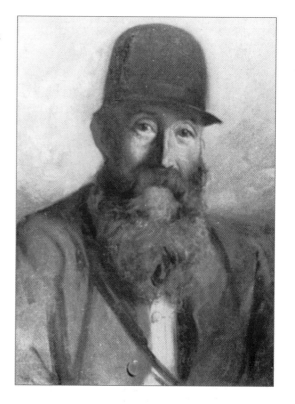

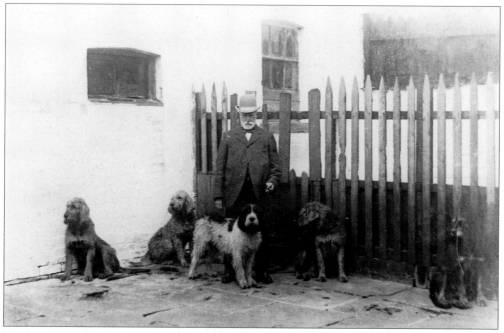

Master of Carlisle Otter Hounds, J.C. Carrick, at the Carlisle Otter Hounds Kennels, Canal Bank, Carlisle, *c.* 1900. He owned Carlisle Hattery, which made bowler hats. Otter hounds are magnificent animals, powerfully built and very strong.

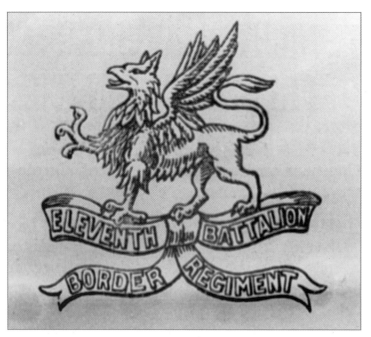

Before the British Army uniform was standardised, Lord Lonsdale established the Lonsdale Battalion of the 11th Border Regiment with its headquarters at Carlisle Castle. He was responsible for its uniform, which was the most flamboyant in the British Army. This was typical of Lord Lonsdale, whose wealth had come from coal mining and who, believing that he had no heir, felt it incumbent on him to indulge in a prodigal lifestyle. So wasteful did he become that when, one day, he suggested to George V that he (Lord Lonsdale), would like to be part of his government, the king replied that he could not afford him. Pictured here is the badge of the 11th Battalion, Border Regiment, depicting a griffin.

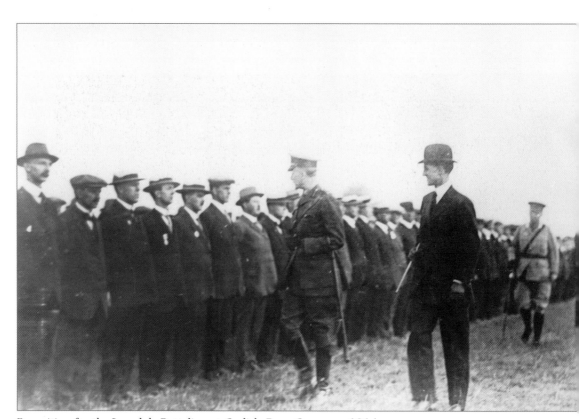

Recruiting for the Lonsdale Battalion at Carlisle Race Course, *c.* 1914.

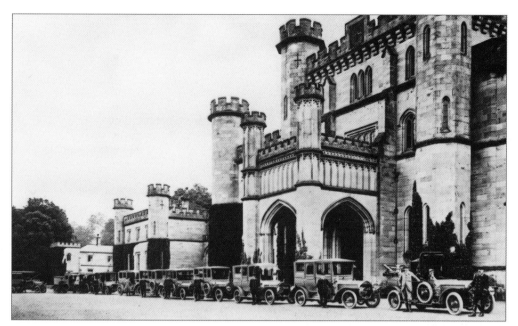

Lord Lonsdale's fondness for yellow earned him the sobriquet of the Yellow Earl. Before political parties standardised their colours, Lord Lonsdale decreed that the colour for the local Conservative Party be yellow. He founded the Automobile Association and its colour was, and remains, yellow. Lord Lonsdale had an interest in boxing and donated the Lonsdale Belt as one of the sport's major prizes. The Rolls-Royces and Bentleys in front of Lowther Castle are all coloured yellow.

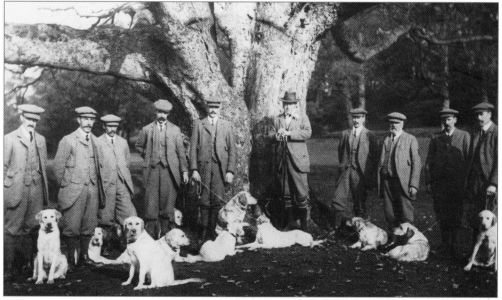

Lord Lonsdale, wearing a yellow flower in his buttonhole, is seen with his nine gamekeepers and their dogs at Lowther. One day Lord Lonsdale accosted a poacher, who punched the Yellow Earl, knocking him to the ground. Getting to his feet, Lord Lonsdale told the poacher that he was just the sort of man he was looking for and made him his head keeper.

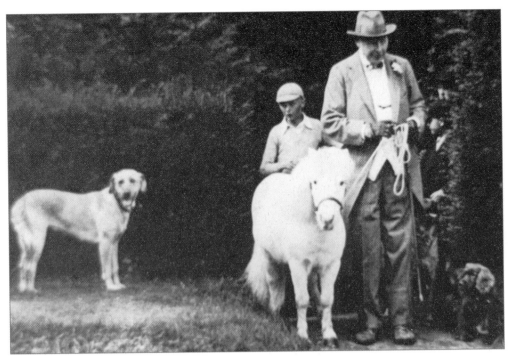

Lord Lonsdale, complete with yellow buttonhole, is with Snowball, his albino Shetland pony.

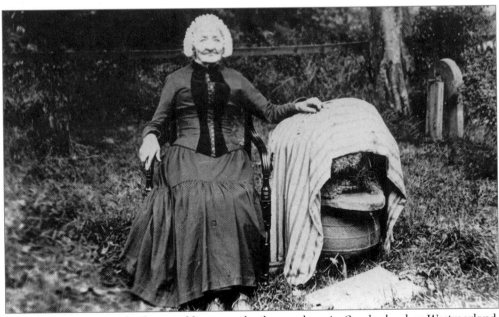

Whenever there was a birth, a wedding or a death anywhere in Cumberland or Westmorland, it was considered important to go to the nearest hive and inform the bees, usually without delay. This lady is waiting to impart some message to a hive, *c.* 1880. All the bees are out gathering nectar, so she has brought her chair and is prepared for a long wait. She makes no charge for the service so the bees don't get stung; but she might. There are up to 30,000 bees in an average hive.

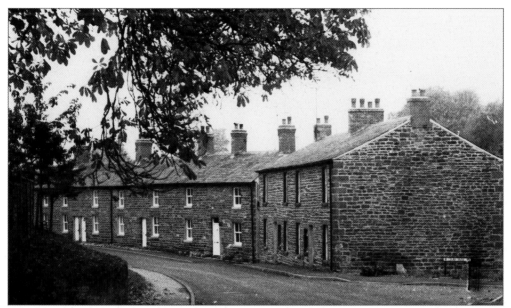

Elizabeth Douglas was born into a wealthy Border family in 1789. She arrived in Brampton as a young lady who had seen better days, though her early life was shrouded in mystery. She never attended church but 'had a high regard for God's word'. While still a young woman she eloped with a schoolmaster, John Baty, to a place near Bewcastle, where they settled and made a living fortune telling. Later, they went to Brampton Fell where John Baty died. Lizzie Baty, as she was then known, lived in their cottage, the end one of Crow-Hall Cottages, until she died in 1817, by which time she had become known as the 'Brampton Witch'.

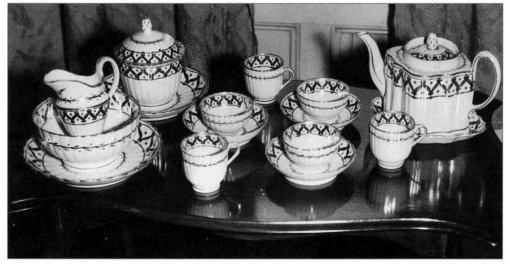

The valuable china pictured here belonged to Lizzie Baty. It was greatly admired by Lady Carlisle, who offered Lizzie a substantial sum of money for it, which was not accepted. When Lizzie died the china was bequeathed to her friend, Joseph Parker; but it was bound by a spell. Should any member of the Parker family drink from the cups, good luck would follow. But if the china ever left the family, it would be the harbinger of disaster for the new owner. The china remains in the possession of the Parker family to this day.

Most of the tales of the Brampton Witch have a macabre flavour. One concerned a farmer's wife who regularly gave Lizzie butter and eggs. At length these presents stopped and soon afterwards 'ill luck visited her [the farmers wife's] house'. Eventually she was found drowned in a well. Another woman mysteriously lost many articles, mainly foodstuffs, and in despair asked Lizzie for help. Lizzie told her that a spaniel had stolen them and told her where the remains could be found. Lizzie Baty's departure from Brampton was as dramatic as her life there. The day of her funeral at St Martin's Church, Brampton, on 6 March 1817, was one of the wildest days in living memory. Lightning flashed, throwing tombstones into stark relief, thunder crashed and Broughton and the surrounding countryside became so dark that mourners had to use lanterns at the graveside.

One day a young girl with an ambition to wear a white bridal gown asked Lizzie to tell her fortune. The Brampton Witch said: 'Thou needn't bother the'sel abboot a white dress. Thou'll git a white dress soon enough.' No one could find an explanation for the old woman's words. But on the following Tuesday the girl caught a cold which developed into a fever and killed her. So she got her white dress, a burial shroud. This is perhaps the strangest of the stories associated with Lizzie Baty: except, maybe, what happened at Lizzie's funeral once the mourners' lanterns were lit. So strong did the wind become that it penetrated the lantern shutters, blowing out the candles, so that they had to be lit again and again. The Baty headstone, seen here, is no longer readable.

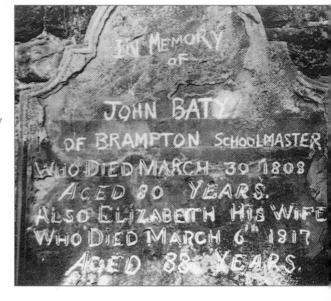

9

Carlisle's Sacred Side

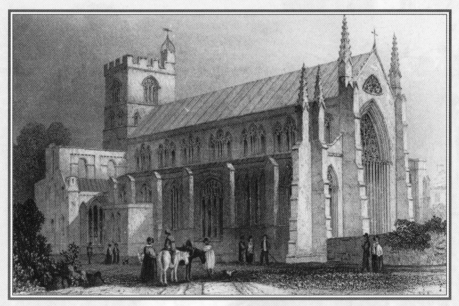

In 1123 Henry I established Augustinian Canons in Carlisle and ten years later
increased the abbey's influence by establishing it as the base for the Carlisle diocese
with the priory church as its cathedral. Most of the present cathedral is Early
English. When the choir was built in the fourteenth century, the central piers did
not settle evenly, being affected by a drought; the Norman arches are still distorted.
During Carlisle Cathedral's early days Blackfriars and Greyfriars regularly met there
for prayer and gossip. As this old print show, what Carlisle Cathedral lacks in size it
more than makes up for in beauty.

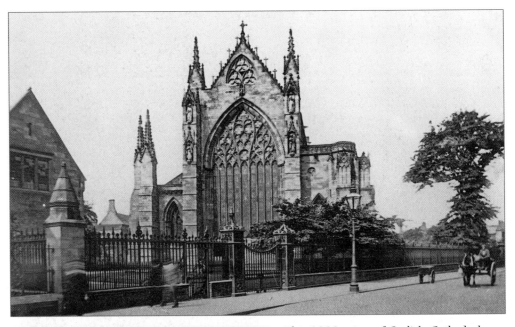

This 1930s view of Carlisle Cathedral highlights its glorious east window. Although situated near the city centre, this impressive building commands the attention.

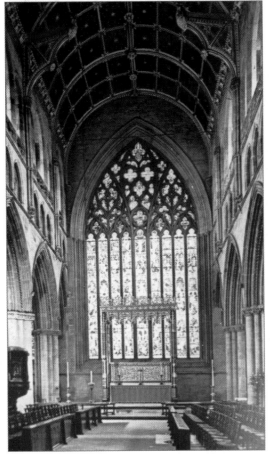

The interior of Carlisle Cathedral looking towards the east window, probably the finest stained-glass window in the world with its nine lights. Some of the glass dates from the fourteenth century.

The South African war memorial in Carlisle Cathedral is a strong reminder of Carlisle's links with that country.

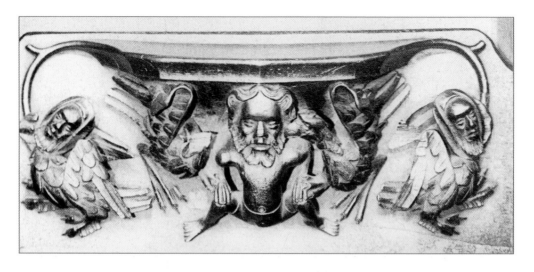

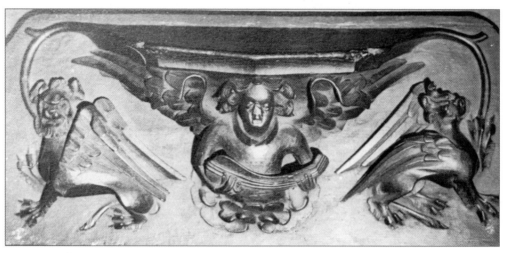

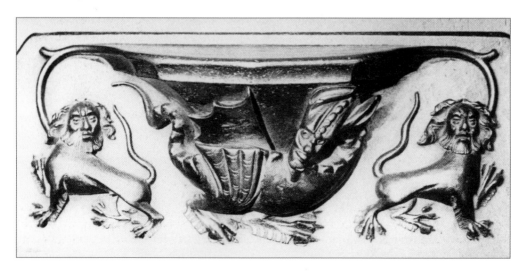

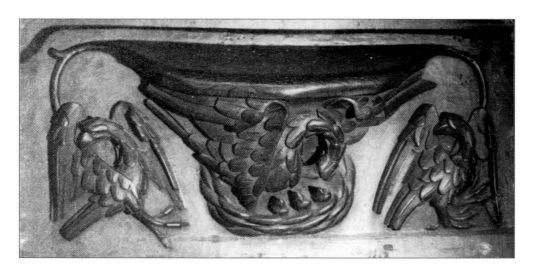

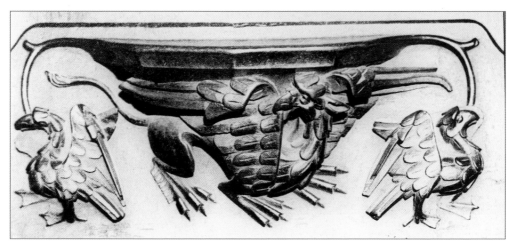

Inside Carlisle Cathedral, the medieval choir stalls are beautifully carved and their undersides are fashioned with forty-six misericords, carved between 1400 and 1420. They depict men, angels, birds, beasts and mythical monsters. The carver was probably allowed to choose his own subjects and was obviously a master craftsman. All these carvings have supporters on each side. 'Misericord' is a fitting word. There could have been little pleasure in sitting on a hard, wooden seat for an hour or more. Along with the misericords, the choir stalls carry fifteenth-century paintings of saints and apostles on their backs. These misericords are fine examples of a master craftsman's work, and the griffin biting its wing shows that the craftsman has a strong imagination.

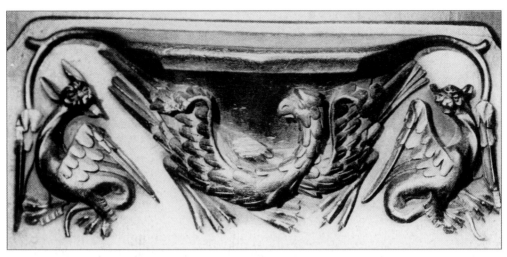

The space (centre left) is where the head of the bird (centre right) should have been.

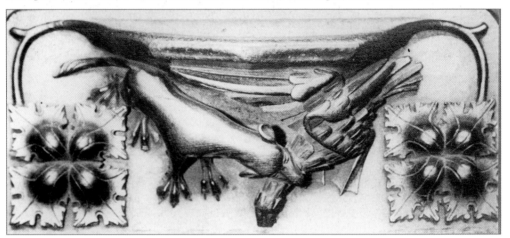

This misericord depicts life and death: life for the fox, death for the goose.

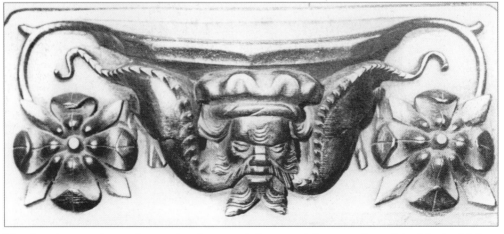

Here two dragons share a human head – enough to convert the agnostic or drive him to drink.

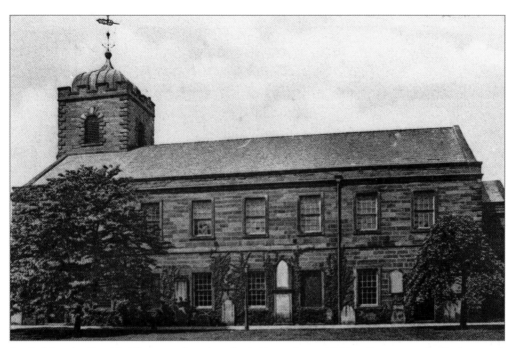

St Cuthbert's Church, the city church, which dates from 1778, when it was rebuilt. In AD 685, two years before his death, St Cuthbert, Bishop of Lindisfarne, visited Carlisle. It is supposed that at the time there was a monastery at or near Carlisle fit to receive Queen Earmenburge, who was staying in Carlisle while her husband, King Ecgfrith, was fighting the Scots. Today there are more churches and holy wells in Cumbria dedicated to St Cuthbert than to any other saint.

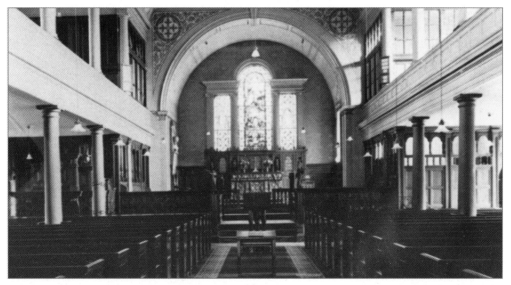

There are two unusual features about St Cuthbert's Church, the interior of which is shown here. A balcony runs along each side of the central aisle and the church is not aligned west to east, which is standard in most Christian churches. The presence of much earlier Roman buildings may have prevented St Cuthbert's being given west–east alignment.

The laying of the foundation stone of the Salvation Army Citadel near the entrance to Carlisle Castle, *c.* 1900. Now Carlisle folk have a choice: 'Onward Christian Soldiers' or 'John Peel'.

Looking up Castle Street from the castle to Carlisle Cathedral. The Salvation Army Citadel, now demolished, is on the right. 'John Peel' won this skirmish.

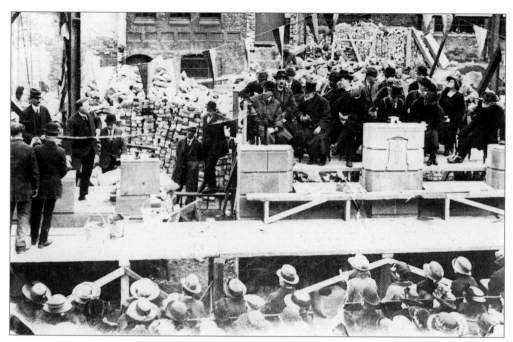

As a consequence of his work among workers at a local munitions factory, the Revd Bramwell Evens was invited to take charge of Carlisle's main Methodist chapel in Fisher Street, only to find himself with a condemned building on his hands. Helped by a wealthy Methodist benefactor, flour miller Joseph Rank, a new building was built and opened on 12 April 1923, completely free from debt (see p. 76). Here the foundation stone is being laid.

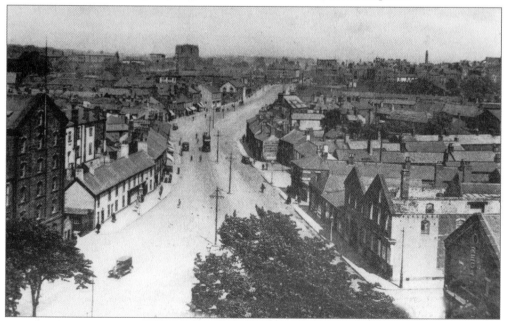

While Carlisle people look to their cathedral, churches and chapels for spiritual guidance, the city's places of worship keep an eye on the people of Carlisle, as this view from the tower of Holy Trinity Church shows.

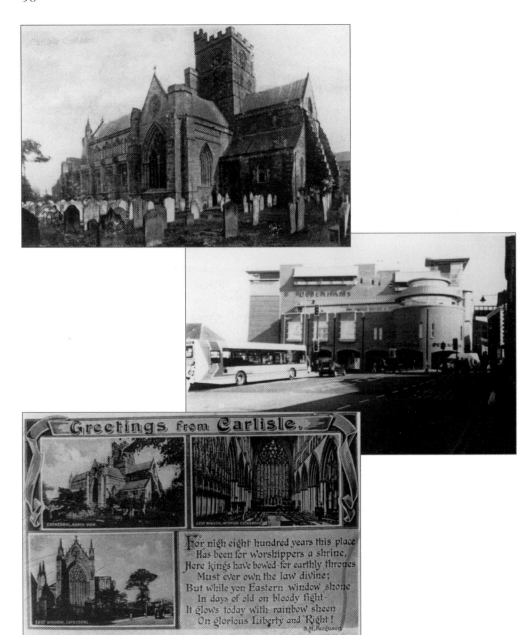

Greetings from Carlisle.

For nigh eight hundred years this place
Has been for worshippers a shrine,
Here kings have bowed for earthly thrones
Must ever own the law divine;
But while yon Eastern window shone
In days of old on bloody fight -
It glows today with rainbow sheen
On glorious Liberty and Right!
S.H.Ferguson

Carlisle Cathedral was founded as an Augustinian priory in 1123 by Henry I, who in 1133 created the Diocese of Carlisle. The priory had several purposes. It was a house of Augustinian canons, the mother church of the diocese and the parish church of St Mary. Following the Dissolution in the 1530s, the priory at Carlisle survived because it fulfilled a diocesan and parochial function. Now as the poem has it:

It glows, today with
rainbow sheen
On glorious liberty
and right.

10

Carlisle's Inspiration

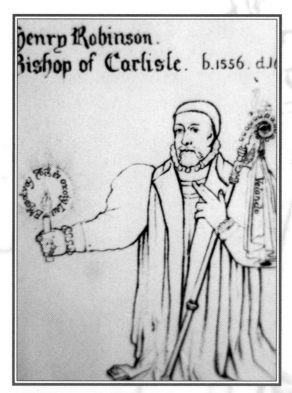

The way a city grows depends entirely on those
who make it grow. Between the sixteenth and
nineteenth centuries many people, like those
depicted in this chapter, inspired those around
them by their example. Bishop Henry Robinson
was born in Carlisle in 1556 and died of the
plague at Rose Cottage on 19 June 1616. He lived
a selfless life of devotion to others.

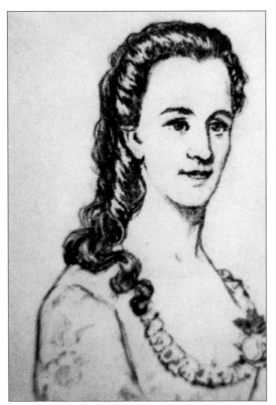

Susanna Blamire was born in January 1747 at Calden Hall near the Oaks, Dalson. Her father was a yeoman. Her mother died while Susanna was still a child and she was sent to live with her aunt at Thackwood. She attended Raughton Head School with her brothers and sisters, and wrote songs and poems, many of which were composed in woodland glades. In later life she lived with a friend, Miss Catherine Gilpin, at 14 Finkle Street, Carlisle, where she died following a long illness in April 1794, aged forty-seven years. A plain stone marks Susanna's grave at Raughton Head churchyard.

Thomas Sanderson was born in 1759, the son of John Sanderson, whose ancestors were of ancient Carlisle stock. The Sanderson family managed their own estate in the village of Sebergham and Castle Sowerby. Thomas was instrumental in the erection of the elegant chapel at Raughton Head. He edited Relph's Poems in 1797 and wrote an essay, 'The Peasantry of Cumberland'. He lived in a cottage which caught fire one night. His neighbours tried to extinguish the fire, but he was badly burned. He was most concerned about a box containing his manuscripts, and when told that it had been destroyed said, 'then I do not wish to live'. He died a short time afterwards, in 1829, aged seventy.

bert Anderson, 1770–1833, wrote: 'At six
:lock on a snowy morning on February 1st,
'70, I first saw the light of day at Dam-side in
e ancient city of Carlisle. I was the youngest of
ne children, born of parents getting on in
ars, who had long been kept in bondage and
verty. At an early age I was placed in a
arity school, supported by the Dean and
apter of Carlisle. My next school was the
aker School: teacher Isaac Watson. I left
hool at ten years old to earn a living and my
st job was with my brother as a calico printer.
the end of a week I received my first wages,
6.' Robert Anderson died in Annetwell Street,
rlisle, on 26 September 1833. A monument
white marble has been erected to his memory
Carlisle Cathedral.

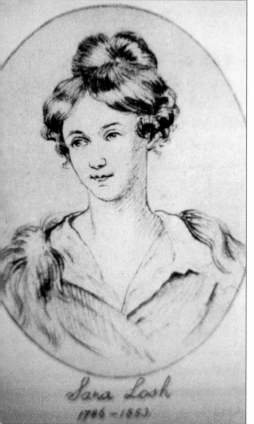

Sara Losh, the eldest daughter of John and Isabella Losh
of Woodside, was born on New Year's Day 1786. She
was baptised in St Cuthbert's Church, Carlisle, by the
Revd Dr Carlyle on 6 January 1786. Miss Losh was
educated first at home, then at Bath and London. Being
very concerned about the necessity of land for
internment, Sara Losh allotted an acre of land at Wreay
as a burial ground that would be available as a free gift
to people in all walks of life. The burial ground has
remained free ever since. Not satisfied with giving the
ground, she built a mortuary chapel of unique design.
Throughout her life Sara Losh performed many good
and charitable deeds. She died on 29 March 1853.

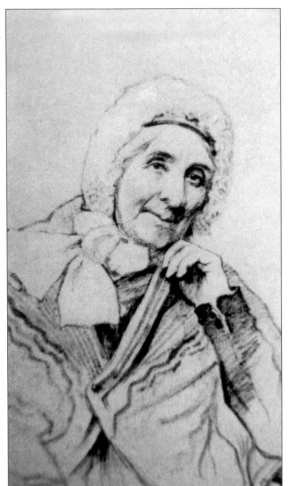

Elizabeth Halton was the widow of Thomas Halton of English Street, Carlisle. Born in 1786, the same year as Sara Losh, Elizabeth was descended from and old and honoured Carlisle family and throughout her long life was associated with upper-crust Carlisle society. Following the death of her husband, Elizabeth moved to 30 Fisher Street, Carlisle. She died on 17 July 1883, within four months of her ninety-seventh birthday.

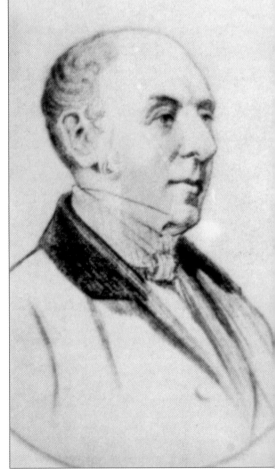

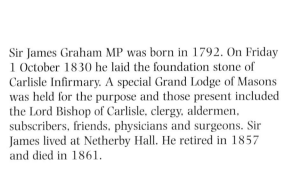

Sir James Graham MP was born in 1792. On Friday 1 October 1830 he laid the foundation stone of Carlisle Infirmary. A special Grand Lodge of Masons was held for the purpose and those present included the Lord Bishop of Carlisle, clergy, aldermen, subscribers, friends, physicians and surgeons. Sir James lived at Netherby Hall. He retired in 1857 and died in 1861.

omas H. Barnes MD was born near Wigton in 1793
d served his medical apprenticeship with Dr Joshua
gg. He served at Waterloo before settling in Carlisle.
e soon became physician to Carlisle Dispensary and, in
320, founded Carlisle's Fever Hospital. He died in 1872.

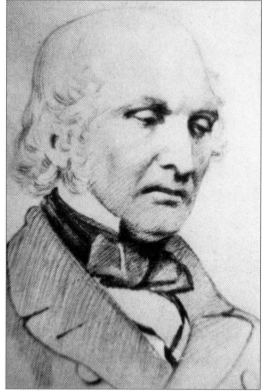

John Woodcock Graves was born in a house next to the
Market Hall in the High Street, Wigton, on 9 February
1795. He published songs and ballads of Cumberland.
The following is a description by John Graves as to how
the song 'John Peel' came to be written:

> John Peel and I sat in a snug parlour at Caldbeck. We
> were then both in the hay-day of manhood and hunters
> of the Old Fashion, meeting the night before to arrange
> the hunt. We were sat by the fireside, hunting over
> again many a good day out with the hounds, when a
> flaxen-haired daughter of mine came into the room
> saying, 'Father, what do they say to what Granny
> sings?' Granny was singing to sleep my eldest son to a
> very old tune called 'Bonnie Annie'. The pen and ink
> for the hunting appointments was on the table and the
> idea of writing a song forced itself upon me; and thus
> was produced, 'impromptu', 'D'ye Ken John Peel with
> his coat so gray'. Immediately after I sang it to poor
> Peel, who smiled through a stream of tears, which fell
> down his cheeks; and I well remember saying to him in
> a joking style, 'By jove, Peel! You'll be sung when we
> are both run to earth.'

John Woodcock emigrated to Tasmania in 1833, settling
in Hobart Town where he died on 17 August 1886.

James Steel was born in Carlisle on 21 October 1797, the son of Archibald Steel, a weaver. James became an apprentice in the *Carlisle Chronicle* office, but the newspaper soon went out of business. James transferred to the *Carlisle Journal*, edited at that time by Jeremiah Jollie. James remained with the *Journal* until 1819 when he moved to Whitehaven as printer and publisher of the *Whitehaven Gazette*. In 1820 he married Barbara Coulthard from Gilsland. In 1826 he left Whitehaven to edit *The Chronicle* at Kendal. In 1828 Jollie died and Steel became the new editor of the *Journal*. During that time he became involved with various meritorious ventures within the city. His voluntary work was acknowledged when he was presented with a plot of land on which to build a house, which he did. James Steel was mayor of Carlisle for two consecutive years, 1844/45 and 1845/46. He died at 3 Victoria Place on 16 December 1851. A granite statue of James Steel faces down Bank Street from English Street.

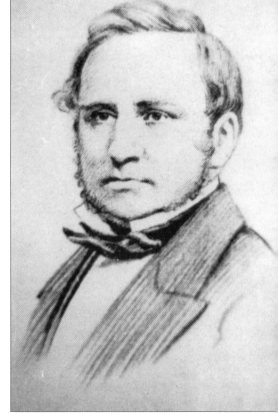

Robert Elliot MD, FRCP, JP was born in Carlisle in April 1811. He was the first medical officer of health in Carlisle. He was a justice of the peace, coroner for the city and in the year 1855 was mayor of Carlisle. Dr Elliot married Eliza, eldest daughter of Mr Dobinson of Stanwix, by whom he had six daughters and two sons. He died on 31 December 1882.

enry Lonsdale MD was born in Carlisle in 1816,
e son of a tradesman. At the age of fifteen he
came apprenticed to Anderson and Hodgson,
rlisle surgeons. He died on 26 July 1876, and is
ried in Stanwix churchyard.

Robert Lattimer was born in Carlisle on 13 September
1825. An ardent lover of music, he was a founder
member of Carlisle Choral Society in 1854. He died on
14 October 1901 in his seventy-sixth year.

William Thomas Best was born in Carlisle on 13 August 1826. His father, William Best, was a solicitor in Castle Street. Best received his first lessons in music from Abraham Young of Carlisle. While still a small boy, Best became organist for the Nonconformist Chapel in Carlisle. He was sent to Liverpool to study engineering but it was obvious that music was his calling. He was appointed organist for Pembroke Chapel, Liverpool, and following various other appointments there he gave three recitals a week at St George's Hall. He worked in Liverpool for forty years, becoming the greatest organist in Britain. In 1890 Best was invited to Australia to 'open' the organ in the Sydney Town Hall. Best retired to Liverpool in 1894 with a pension of £240 a year. Following much suffering, he died on 10 May 1897 and was buried in Childwell parish graveyard.

Thomas Bulman was born at Stanwix, Carlisle, on 23 October 1827. He lived through the reigns of five sovereigns, becoming chief clerk of Carlisle district probate registry. He regularly attended services at St Mary's when it was in the nave of Carlisle Cathedral. A stained-glass window was erected to his memory in St Mary's Church by solicitors of Cumberland and Westmorland. Thomas Bulman died in 1920.

r Wilfred Lawson, of Brayton Hall near Isel, was
rn on 4 September 1829. He was educated at
me and at an early age entered political life,
ing returned as one of the Liberal candidates for
rlisle along with his uncle, Sir James Graham.
r Wilfred Lawson was a man of great character
d it is said that he broke no promises, served no
ivate end, gained no titles and lost no friends.
ow many politicians today can live up to those
gh ideals?

Richard Soul Ferguson, the eminent archaeologist,
was born in Carlisle on 28 July 1837. He loved his
ancient city and introduced the cotton industry into
the Carlisle area. He was educated at Carlisle
Grammar School and Shrewsbury, where he obtained
a scholarship to St John's College, Cambridge. He took
his BA in 1860, his MA in 1863, his LLM in 1874
and was called to the bar. He was a writer and
historian and twice became mayor of Carlisle in
1881/2 and 1883/4. He was made an honorary
Freeman of Carlisle and died in 1900.

The Rt Hon. and Rt Revd Mandell Creighton DD was born in Carlisle on 5 July 1843. This bishop and historian was the most eminent of all Carlisle's sons. Creighton was made Bishop of London in 1896. In the late summer of 1900 he fell ill and died at Fulham Palace on 14 January 1901. He was buried in St Paul's Cathedral where there is a statue over his tomb.

Edward Prevost PhD, FRSE was born in Newtown House, Carlisle, in 1851. He was a compiler of the *Cumberland Dialect Glossary* and was also a member of the Royal Photographic Society. He died in 1920.

11

Blossoming Carlisle

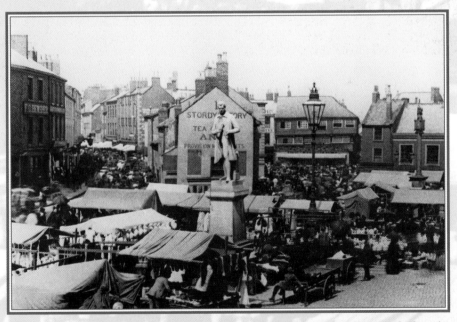

James Steel's monument dominates this view of Carlisle's open market and Glover's Row, *c.* 1886. An open-air market was held on this site from the Middle Ages until 1927 on Wednesdays and Saturdays.

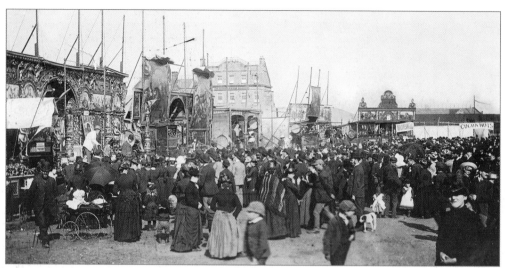

Life was not easy in nineteenth-century Carlisle, despite growing employment and better transport. It would have been almost unbearable had there been no relief from the daily grind of making ends meet. It is human nature to kick over the traces once in a while and one way of doing this is to sample all the fun of the fair. That is what these usually thrifty people are doing at Carlisle Fair on the sands, near the Turf Hotel in 1889.

It is 1890, the setting sun is casting long shadows and Overtello is selling ice cream, which can be licked but not beaten, from his barrow at Carlisle Cross. On the left is Blakey's shoe shop in Glover's Row; Mr Blakey invented Blakey studs for shoe heels. In the background are the pointed spire of St Mary's Church and the tower of Carlisle Cathedral.

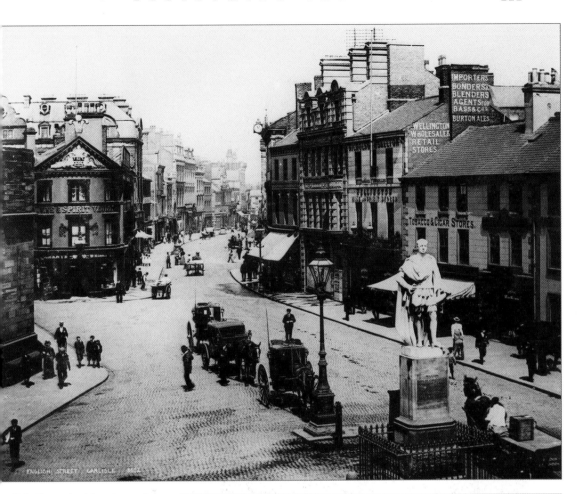

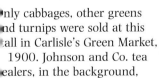

nglish Street looking towards
ne middle of Carlisle, 1895. In
ne centre are three horse-
rawn hansom cabs while to
ne right of the handsome
reet lamp is the statue of
Villiam, Earl of Lonsdale;
arlisle gaol is on the left.

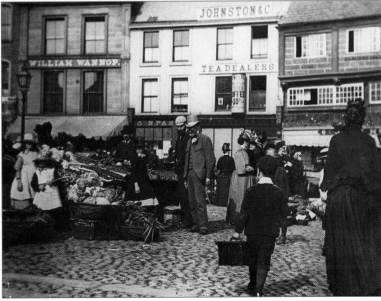

nly cabbages, other greens
nd turnips were sold at this
tall in Carlisle's Green Market,
 1900. Johnson and Co. tea
ealers, in the background,
ad coffee on offer at 10*d* a lb,
n example of 'if you can't beat
he opposition join it'.

Foremost among the small businesses that were becoming established in nineteenth-century Carlisle was Charles Thurnam, printer and bookseller, whose other commercial interests were stationery, publishing and running a circulating library. Businesses like Thurnam's were as crucial to the commercial life of Carlisle as its hotels and banks. Thurnam's business premises were in English Street. They still trade from 26 Lonsdale Street. Other business concerns were interested in operating in Carlisle, one of these being WH Smith & Son whose premises are seen here in English Street in about 1910.

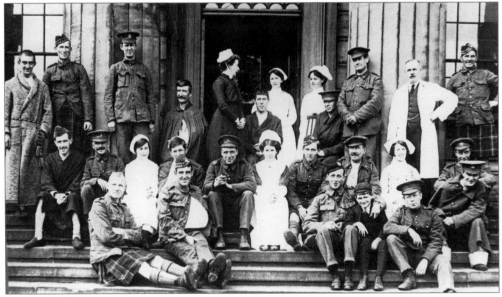

The foundation stone of the Cumberland Infirmary was laid on 1 October 1830 and the building was completed on 8 November 1832. However, the first patient was not admitted until 1841, because of a court action with the contractor. In 1860 Cumberland Infirmary had only two day nurses and an old woman, addicted to smoking a clay pipe, who was on permanent nights. In 1915 there was a serious train crash at nearby Gretna and the survivors requiring hospital treatment were brought to the infirmary. Here, survivors in military uniform are seen outside the Cumberland Infirmary with matron and nurses.

s industry developed in Carlisle, so
ew the need for banking. Wakefield
d Co. Bank, Carlisle's first bank,
ened in 1788. By 1811 there were
e banks, all privately owned. Sadly,
t all were properly managed.
wards the end of 1836 commercial
nkruptcies had caused panic among
arlisle's financiers. Such was the run
Foster's Bank that it had to
spend payments. The crisis was so
vere that of all Carlisle's banks only
ead's Bank survived. Head's
bsequently became London City and
idland Bank (now HSBC), seen here
about 1920. It is situated at the
rner of English Street and Bank
reet. G. Collins & Sons, tailors, next
the bank, were selling suits for 42s
d overcoats for 30s.

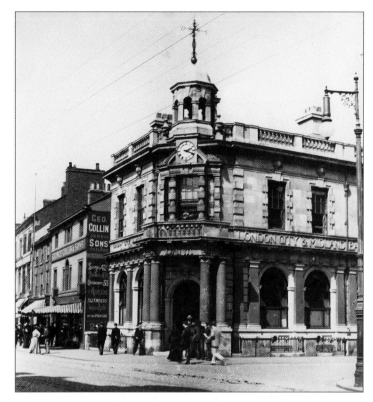

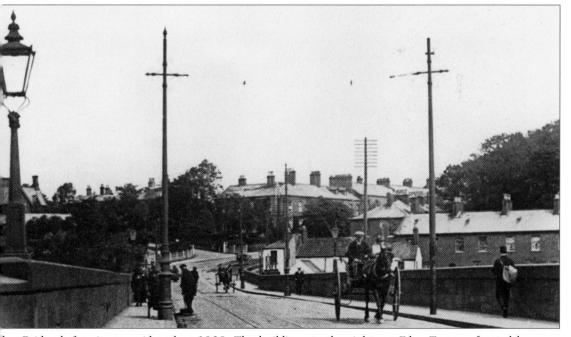

len Bridge before it was widened, c. 1920. The buildings to the right are Eden Terrace, fronted by some
ttages. The two lots of people driving horses and traps across the bridge into Carlisle are probably country
lk. Also on Eden Bridge is a postman delivering the morning mail.

In 1836 the Carlisle end of the Newcastle & Carlisle Railway line was opened. This first rail link to Carlisle was followed, in 1845, by the Maryport to Carlisle line, and in 1847 Carlisle's main railway station, the Citadel, was opened. Eventually, seven railway companies were operating from Carlisle. This railway development stimulated industrial growth. John Blaycock, watchmaker, provided all station clocks and ticket machines between Carlisle and Preston. In 1859 John Blaycock and William Pratchitt established an ironworks that made much of the ironwork for many northern railway stations. In 1846 Cowans Seddon Engineering Works opened and made axles, wagon wheels and railway turntables. When Jonathan Dodgson Carr settled in Carlisle in 1831 and opened his Steam Biscuit Factory in Caldewgate, his business would not have developed as quickly as it did nationwide had Carlisle's rail links not been as good as they were. This view of Carr's Biscuit Works looks west towards Trinity and Caldcoats, in about 1950.

These Carr's employees are from the cardboard box department, *c.* 1920. The man in charge (front row, centre) is Mr W. Clark.

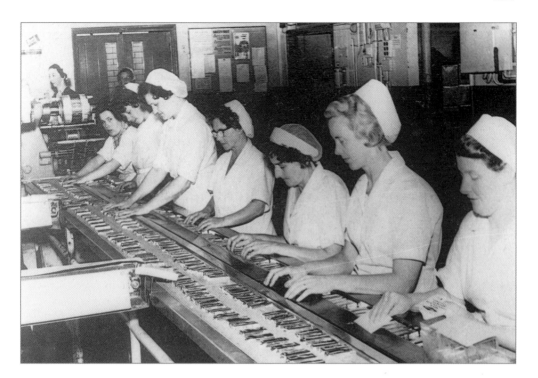

Working on Carr's biscuit assembly line is a dream of a job. Most of the ladies shown here can do it with their eyes shut.

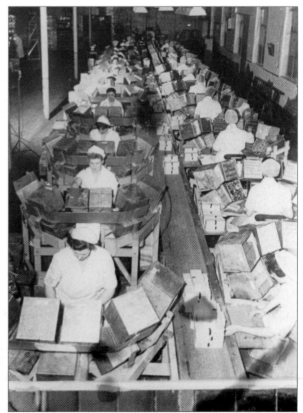

Carr's biscuits being packed from one of the conveyor lines. Carr's had been established in Carlisle for just a decade when the firm was granted the Royal Warrant. By 1846, 400 tons of Carr's biscuits were being made annually. When the factory opened, all the biscuits were cut by hand. Then someone adapted a printing machine to cut biscuits and production soared.

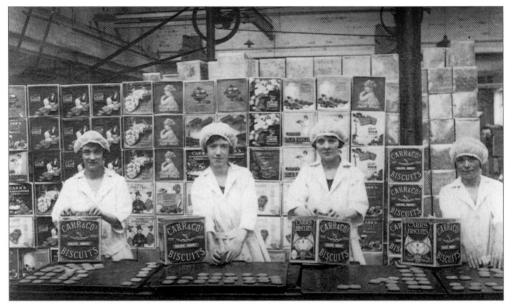

Packing Carr's biscuits in the 1930s. Behind the ladies is an assortment of tins, each with its own fancy label.

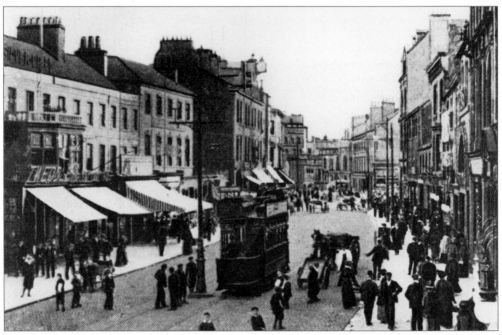

A tram passing a horse and cart on English Street in about 1925 symbolises Carlisle's enlightened attitude to change. English Street, a northern extension of Botchergate, is one of the city's main thoroughfares. It leads south from the city's market place, gently curving left, passing to the right of one of the round Court Towers, near Citadel station, to join Botchergate end on. This famous street, which cuts through the middle of Carlisle, dates from medieval times and is steeped in history.

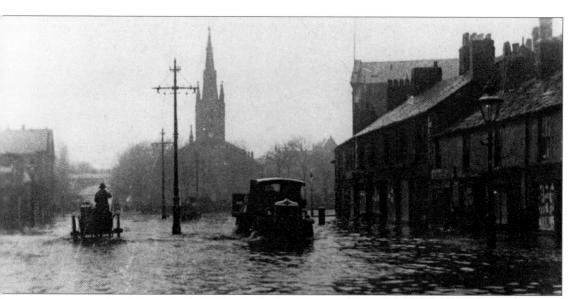

Many Carlisle folk got a rude awakening on New Year's Day 1925, when the Rivers Eden, Caldew, Petteril and all the adjoining becks burst their banks. This view was taken in Caldergate looking towards Trinity Church. Anyone telling a first footing reveller to take more water with it was simply asking for trouble.

From 1462, when Carlisle first had a coat of arms, there have been four different versions. The motto under the present arms is taken from Shakespeare's *Henry VIII*, Act 3, Scene 2, where Cardinal Wolsey tells Cromwell:

Be just and fear not,
Let all the ends thou aims't at be thy country's,
Thy God's and truth's.

Carlisle's mayor and mayoress, wearing their chains of office, in 1928. In 1849 the then Mayor of London invited provincial mayors to a banquet in honour of the Prince Consort. The Mayor of Carlisle had no chain of office, so he hired one for the evening. At this time, Carlisle Gas Co. was being handed over to the Corporation, and having some surplus cash, decided to present a mayoral chain and badge for use on civic occasions. It was first used on 10 October 1850 by Joseph Rome to welcome the Duchess of Kent, who was breaking her journey at Carlisle station. A new chain was purchased in 1898 and is the one in use today. It carries the unauthorised arms of two shields.

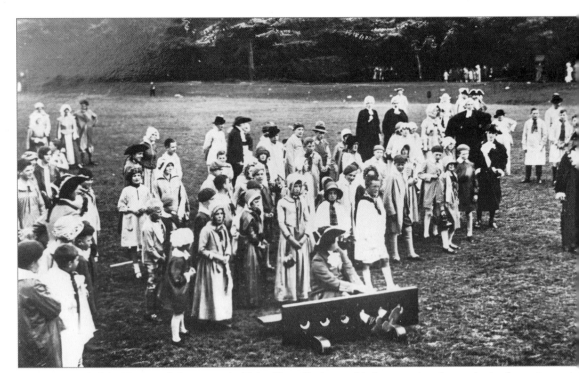

In 1928 Carlisle's Historical Pageant, held in Bitts Park, enabled many local people to dress in peric costume and re-live history, not as it was but how they would have liked it to have been. The pageant wa an escape from the growing economic problems that would soon cause havoc throughout the world.

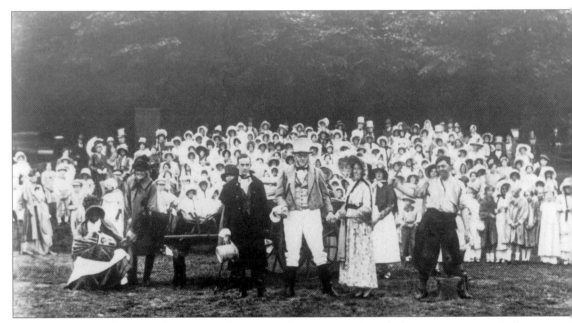

There were many facets to the Historical Pageant, the one seen here being a re-enactment of a runawa marriage to Gretna. The father and his wife, centre, have lost a daughter, the blacksmith has lost a hors the man, front right, has lost his son and the massed ladies in the background have lost the plot.

12

Where Ancient & Modern Meet

Like the New English Hymnal, Carlisle is a rare blend of ancient and modern, and it is this rare mix of old and new that has transformed this 'City of Waters' into the fascinating place that it is today. In 1516, the original bridge over the Eden at Carlisle was 'decayed and part fallen down'. A replacement, the present Eden Bridge, was built and, in 1932, widened to double its width to accommodate the increased volume of traffic. A bridge has spanned the River Caldew since the Middle Ages. In 1926 this ancient bridge was replaced by the present one.

In 1321 Rose Bridge, over the River Caldew, was in danger because it was sited less than ¼ mile from Rose Castle. The castle's curtain wall was in a poor state of repair and two sections, one 40ft long and the other 120ft long, were in imminent danger of collapse. Rose Bridge (above) survived. In 1820 Caldew Bridge and St Nicholas Bridge were built over the Caldew. Caldew Bridge was rebuilt in 1926 and St Nicholas Bridge in 1927.

In 1916 the government set up a Central Control Board to regulate the consumption of liquor in and around Carlisle. The State Management Scheme, as it was called, lasted until 1971, during which time more than a third of Carlisle's pubs, many hotels and the city's four breweries were run by the Board. The brewery alongside the River Caldew (above) has been converted into flats from which residents are able to watch water fowl and otters.

One of Carlisle's strong links with its past is this monument on Burgh Marsh. It marks the spot where Edward I, 'Long Shanks', died when en route to do battle with the Scots.

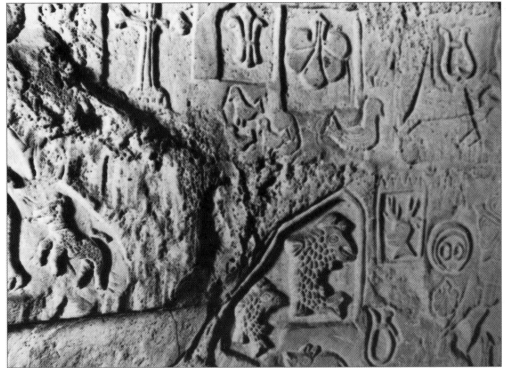

On 17 November 1745, Charles Edward Stuart entered Carlisle at the head of his 'hundred pipers an' a'' and proclaimed his father James III from Carlisle Cross. On 22 November 1745 he moved south to defeat. His cause lost, he retreated, leaving 400 men to delay the Duke of Cumberland, who reached Carlisle on 21 December 1745. The Jacobites surrendered on 30 December 1745. During his stay in Carlisle, the Duke of Northumberland stayed in Highmore House and slept in the same bed as Prince Charlie had done. Following the recapture of Carlisle, many Jacobites were imprisoned in the cells of Carlisle Castle where, to pass the time, they cut carvings into the cell's walls, as shown here. Many of the Jacobite prisoners were later hanged, drawn and quartered.

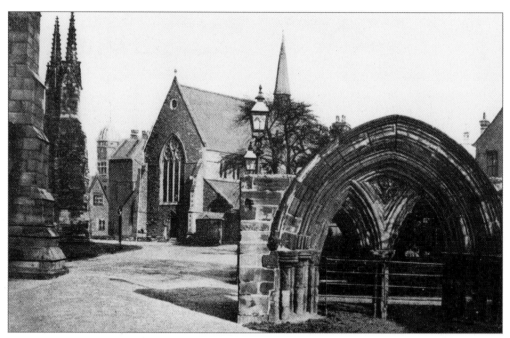

In biblical terms, this picture shows St Mary's Church, the 'David' of Carlisle's churches, seen from the grounds of Carlisle Cathedral, the 'Goliath' of Carlisle's places of worship. Unlike Carlisle Cathedral, St Mary's Church has had a short history. It was erected in 1869/70 and closed for worship in 1938. Carlisle Cathedral remains, giving the 'David and Goliath' story a new twist. This time 'Goliath' is the winner.

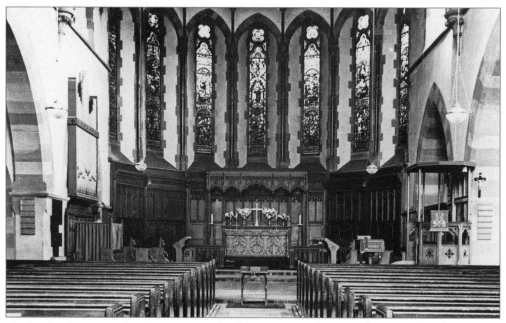

The last wedding to take place in St Mary's Church, the interior of which is seen here, took place on 30 July 1938, when a couple tied the knot to become Ken and Mabel Hodgson. Sadly, this fine church was demolished in 1954.

At one time, dovecotes were found throughout the country, usually attached to estates, large houses, vicarages and the like. They were used for housing large numbers of doves, usually 200 or more, kept as a stand-by source of food, especially during winter snowstorms. The splendid Doric-fronted dovecote seen here in the grounds of Corby Castle, near Carlisle, is probably the best example in the country of a dovecote still in working order.

The doves enter the dovecote through any one of six rectangular gaps close to the top of the rear gable end and, once inside, they have a choice of 750 nesting boxes.

Barnacle geese, on the Solway Marshes, graze together close to the shore, feeding mainly at night. The barnacle goose owes its name to a medieval myth. Our forebears thought that, unlike other birds, the barnacle goose did not come from an egg. It was generated from the curiously shaped goose barnacle. The 2,500–3,000 barnacle geese, which arrive on the Solway each winter, come from their breeding grounds in Spitzbergen, Norway.

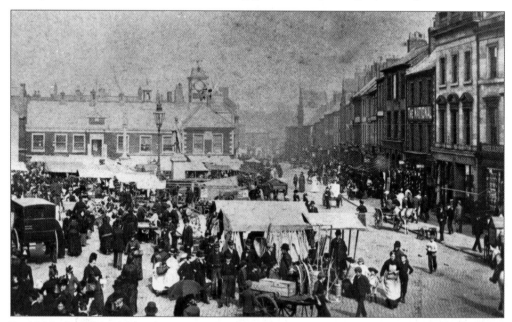

In 1882, Carlisle Market Place was a bustling place, the stalls gathered around the Market Cross being thronged with shoppers. The building behind the Market Cross is the old town hall. For centuries a town hall, or moot hall, occupied part of that site. Then in 1717, the town hall was extended and, in 1881, the square belfry was added.

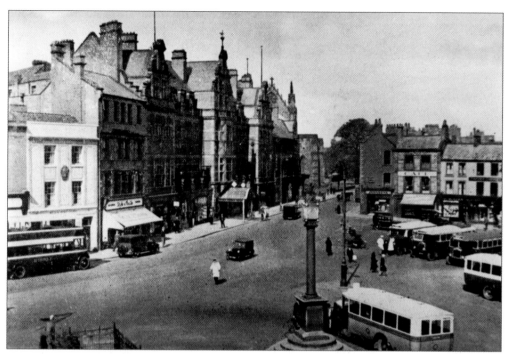

By the 1930s all traces of the open market had disappeared and buses were being parked close to where the stalls used to be. The large building with a canopy is the Crown and Mitre, which commands the northern end of English Street.

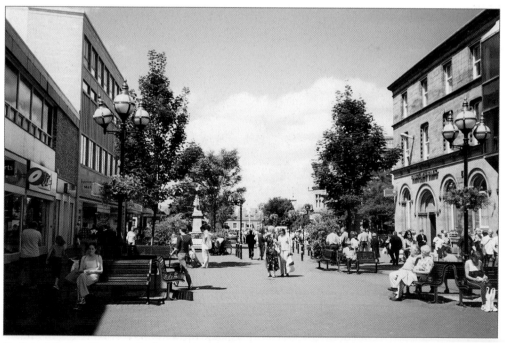

Carlisle Market Place with the Market Cross overlooking a most inviting pedestrianised city centre, 2002. It is an impressive yet restful place, one of Carlisle's many joys.

Today Carlisle enjoys a new concept in shopping, provided by the purpose-built New Lanes Shopping Centre. It is rated as one of the best shopping centres in Europe.

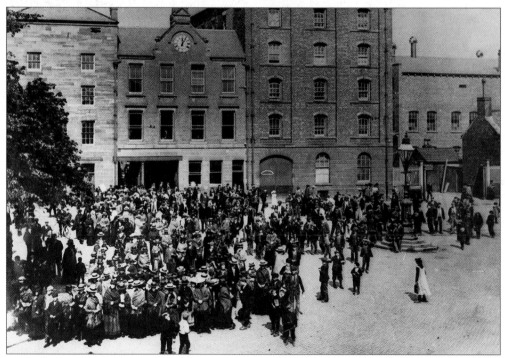

Carr's Steam Biscuit Factory in Caldewgate had been in production for 105 years when this picture was taken in 1936. During the last quarter of the nineteenth century Hudson Scott built up a tin plate manufacturing industry that became the forerunner of the Metal Box Co., one of Carlisle's biggest employers. Another very important Carlisle industry, Lynton Tweeds, which continues to produce very high-quality tweeds and fashionable dress materials from its textile mill, is the only one left in Carlisle. There is a big demand for these thick, woollen cloths, which are exported throughout the world, especially to the Far East. All three factories continue to do good business. Civil engineering giant Laing began in a small way at Sebergham in 1848, then moved to Carlisle where it expanded into the international firm it is today.

This quiet corner of Carlisle features the gatehouse to Carlisle Cathedral, also known as Prior Slee's Gate after the prior responsible for building it in 1528. It stands at the end of Dean Tait's Lane and the corner of Paternoster Row and Abbey Street.

Carlisle's Guild Hall or Redness Hall (centre), in 2002, is as much a part of twenty-first-century Carlisle as the surrounding buildings. Yet it was built in the fourteenth century. This glorious harmonising of ancient and modern enriches Carlisle and enhances its appeal.

Modern Carlisle is a city of great charm as this view of the Market Cross (left), English Street and Bank Street corner (right) shows. It comes as no surprise, then, that, when away from home and asked where they come from, Carlisle folk are quick to point out that they hail from one of the finest cities in England and the word 'Carlisle' is spoken with understandable pride.

Pedestrianised Carlisle city centre is a restful place, especially made for shoppers, sightseers and young lovers. There is a relaxed atmosphere about the place that is catching. But in Carlisle it is the fisherfolk who have the best of it. Carlisle's three rivers, the Eden, shown here flowing past Rickerby Park, the Caldew and the Petteril, are all famed for their salmon and trout. So addictive is the fishing, so beautiful the riverside scenery, and so filled with contentment are the fishers that they now use a fisherman's prayer that seems fitting:

God grant that I may fish until my dying day,
When in the Lord's safe landing net
I'm peacefully asleep;
And that in His mercy I may be judged
good enough to keep.

Amen to that!